MW01106216

Sumbawanga Safari

Betty Kilgour

Detselig Enterprises Ltd.

Calgary, Alberta, Canada

Sumbawanga Safari

Canadian Cataloguing in Publication Data

Kilgour, Betty

Sumbawanga safari

ISBN 1-55059-142-8

1. Kilgour, Betty—Journeys—Tanzania. 2. Tanzania—Description and travel. I. Title.

DT440.5.K45 1996 916.7804'4

Detselig Enterprises Ltd.

210-1220 Kensington Rd. N.W.

Calgary, Alberta T2N 3P5

Detselig Enterprises Ltd. appreciates the financial support for our 1997 publishing program, provided by Canadian Heritage and the Alberta Foundation for the Arts, a beneficiary of the Lottery Fund of the Government of Alberta.

Printed in Canada

ISBN 1-55059-142-8

SAN 115-0324

Dedication

This book is dedicated to my Kilangala family, with love.

Acknowledgements

As with all my books there are many people I wish to thank for many reasons –

My heartfelt thanks go out to Ted Giles, my wonderful publisher, for his expertise and continuing faith in me as a writer. Indeed, many thanks to the whole staff at Detselig for their help, friendship and acceptance – May Misfeldt, etc. – and to Linda Berry for her editing skills and gentle way of adjusting this manuscript.

To Ben Crane, my old friend, for yet another amazing cover!

To Sultan, Yasmin and the boys, who once again opened their home and hearts while I was in Dar and for accepting my girls simply because they belonged to "Betty Aunty."

To Johnson and Roza – the heartbeat of Kilangala and Kitembo Missions, for accepting this *mzungu* with love and friendship.

To Moses – my Tanzanian "son," for his special care and friendship and also for his map of the mission and several of the photos used.

To Doctor Reedyk, for taking time out of his busy practice to write such an intuitive foreword for this book.

To Jim Butler, for his expertise and patience sorting photos.

A special thanks to all who have contributed in so many ways toward my Kilangala projects over the years.

And last but not least, my love and thanks to my whole family, who always rally behind me when I flip off on some adventure, be it physical or mental.

And to my Bill, for sending me off with his love and for just being behind me for all these years.

Table of Contents

Foreword

Betty has done it again. With her superb powers of obser-
vation and inimitable wit, she transforms a trip to East Africa
into a hilarious but serious glimpse of African life. As a former
resident and a periodic visitor to Africa, I can vouch for the
accuracy of her observations. In fact, I found myself gaining
new insights into some African customs from her book.

Take a Canadian farmwife with a flair for the unusual and
little sense of danger, mix with a generous portion of real life
Africa, add in the oil of compassion, season with a good
measure of the ridiculous situations she manages to get herself
into (why does she always seem to find them while most of us
live such mundane lives?), bake in the hot African sun for 6
weeks and you have a spell-binding real life adventure that
will give you some valuable perspectives on African life.
There were times when it was impossible to continue reading
because I was laughing so hard.

If you are interested in travel, Africa and in good, clean
humor, this is a book you must read.

Martin Reedyk, M.D.

Editor's Note:
Dr. Reedyk spent 8 years in Africa as a missionary doctor.

On a Wing and a Prayer

Just when the urge to make yet another trip back to Tanzania hit me, I'm not sure. I thought I had successfully quenched that thirst when I paid a return visit in 1989 with my friend Mumtaz (*From Dar To Zanzibar*), but as many have found, Africa is not like other continents – it never allows you peace.

Africa has called me for years, even as a child, before I was old enough to know what the strange longing was. I had read all the old "White Hunter" books, from Teddy Roosevelt's to McMillan's. I paddled down crocodile-infested rivers with Mary Kingsley, a scientifically-minded Victorian spinster with a zest for life and a great sense of humor, who set out for Africa in 1893. Her main interests were zoology and anthropology, and she showed, for all time, that women too could survive and actually enjoy safari life. Mary travelled light, just a leather portmanteau and a waterproof sack containing blankets, boots and books. Her jungle outfit consisted of a high-necked white blouse, a heavy ankle-length black skirt, tall laced-up boots and a cummerbund, which she used as a towel when bathing in the dark swampy rivers.

One day, Mary plunged into a fifteen-foot deep game trap, but the thick folds of her skirt protected her from the foot-long ebony spikes at the bottom. For protection, she stuck a pistol and bowie knife in her waistband. Most of her travelling was on foot or in a canoe and she was said to have been fearless.

"Being human she must have been afraid of something but one never found out what it was," Rudyard Kipling said of Mary Kingsley. Yes, she was quite a woman and I'm sure I wasn't the first young impressionable girl to idolize her. I stood beside Chinese Gordon as he awaited his death with such style and composure in Khartoum, and Livingstone – I walked miles with that magnificent man!

What missionary books I could find, I devoured, and one old tattered copy of a book on Mary Slessor was my favorite. What an example of independence and missionary zeal that little lady was. Tiny, just under five feet, Mary was born in Aberdeen, Scotland, in 1848. Independent, she dared what few would think of even now. She was determined to follow in the footsteps of fellow Scot Dr. Livingstone, and by golly she did, sailing away to West Africa in 1848 at the age of 28. She not only spread the gospel everywhere she went, but practically put a stop to twin murders by herself and was even called upon by the British government to settle disputes between tribes, many of them cannibals. I loved her spirit. She was even known to box a few ears, even though she had to reach high to do it. I thought those early missionaries were marvellous. I could just picture them striding across the vast African continent, bible in hand, singing "Onward Christian Soldiers" lustily! In fact, at one time I actually hoped to become a missionary. That was after my hopes of becoming a movie star and before my wish to become a big-league baseball player – playing left field, of course.

As an adult with imagination and spirit slightly reined in, I still craved anything African, only now it was mixed with a deep desire to help my fellow man. I felt missions to be an integral part of every church. However, you'll never hear as much as one Hallelujah leave my lips, nor will you see me "caught up in the spirit," eyes closed, arms aloft. That's not the Presbyterian way! Put me in a pulpit and I'll knock your socks off, but otherwise no show – we Presbyterians have visions of Pharisees when we view such displays, but keep in mind we have only just started going hatless to church and smiling in photos!

But when we were posted to Tanzania in 1976, my love for the country and my beliefs came together. I saw first hand the marvellous work the mission stations were doing. I saw the great need and felt deeply for the little orphan children and poor villagers and wished I could improve their lot. There I had the wonderful opportunity to visit a mission outside Sumbawanga and I was drawn to these people. On returning to Canada, I was dismayed to hear remarks like "missionaries do more harm than good" or "Leave the Africans alone – they don't need your religion!" I knew different and through the ensuing years I tried in my own small way to assist my friends in their humanitarian work. So I thought, I will go with an open mind, and watch and listen and try to evaluate whether missionaries and missions are as dedicated, helpful and as necessary as I feel they are. So when the longing to return to Africa became a raging torrent, I used them as an excuse!

1. I needed to visit Kilangala just to see if the goods I had sent were useful and find out where else I could assist.

2. I could try to meet with Joyce Mbani, my old friend of those long ago years.

3. I could visit the old ranch and Sumbawanga town.

4. I could visit my friends, the Jiwas, in Dar. It was six years since I was there.

5. I would also find out if I could squeeze yet another book on Tanzania out of my trip, and finally, as if I needed any more excuses,

6. I could try and prove a white woman of questionable years could actually travel alone to Africa, and cross the country of Tanzania without mishap!

It didn't take long to convince myself of the necessity to pay Tanzania another visit. Then came the flurry of preparations. I found I needed a visa to enter the country, something new since my last visit, but what a dandy way for the country to bring in some much-needed revenue! On inquiring at our Health Unit, I found I only needed a few booster shots and a

gamma globulin one, which was administered while I lay flat on my stomach on the floor!

"Much easier this way," Kathleen, the nurse, told me. I didn't ask her, easier for who?

But Africa was well worth the pain! I spent days buying gifts for all my friends, all sorts of neat things I thought might be useful at the mission, even a real old-fashioned scrub board. I knew one fellow did all the orphans' laundry and felt a scrub board might be just the ticket. I picked up all sorts of little things for the children who might cross my path, balloons, little toys and even cheap watches, remembering how scarce many items were when we lived there. And my clothes; I always take too many when travelling. I always feel I might need this and that, something for every occasion, but usually end up with outfits which are of no use and not the items I really need. But that's part of the joy of travelling, isn't it?

I was to fly out December 26 and I was all packed by Christmas Day – I was also a basket case! We spent the day with the whole family and then came the goodbyes. Christmas always brings out mellow feelings in our family and by the time we were through with our goodbyes, I was adrift in tears. Little remarks like, "Mom, you won't have enough to eat!", and "Oh, do be careful!!" didn't help me. I knew and they knew we wouldn't change a thing and I was only going for six weeks, but the whole thing took on the aspect of a departure from the old country at the turn of the last century, never to return again!

Of course, I could have stayed home like a sensible farm wife, but the call of Africa was just too strong. The twenty-sixth found Bill and I at the airport, bags stuffed, locked and marked with iridescent orange pom-poms, so I'd recognize them easily. As I kissed Bill good-bye and walked bravely off, it was all I could do to keep from running back into his arms whining, "Take me home!!"

As I came to security, I held my bags tightly to my bosom. "Will my slide film be safe going through?" I asked. I had

ample reason to worry, because if they were ruined, I had a snowball's chance in Hades of getting replacements in Tanzania. After about my tenth inquiry, "Are you absolutely sure?" the poor man muttered, "YES, MADAM" through tightly clenched jaws as he literally pushed me and my bags through the security gates and turned away, eyes rolling to the heavens. In the departure lounge, I relaxed with a big sigh of relief.

"I got here, I'm not late, my bags are hopefully on the same plane as I'll be boarding – Wow, I made it!"

As we boarded, I peeked into first class – I never travel first class, but I'm intrigued by those who can – and it was almost empty, only two lone men. They should join us commoners – we have lots more fun, I think! I was surprised to see only men stewards on duty. My, they were impressive, polished English accents, and heads held high with dignity and hair spray – well, one had hair, the other had a round butterball dome with two fine strands of hair combed meticulously down the center, which he kept smoothing into place, sort of a security blanket. If a strand moved and fell back the poor man would have lost his mask and we would all see into his soul.

It didn't take me long to realize my purse was going to give me trouble. It was too big to slip under the seat in front of me, but held all the paraphernalia I thought I might need for the flight. It was dreadfully heavy and much bigger than my carry-on, but I've travelled enough to know your luggage takes trips to places you never will and many times you find yourself baggageless on arriving. So I had packed a change of clothes, as well as all the little stuff we women can't live without. I always take a mobile pharmacy with me, something for every ailment and disease known to man – just in case. I rarely ever need it, but it gives me a feeling of security. Add all the make-up and perfume I need and I could stock a fair sized *duka* (store). The only problem was, I could barely lift it. Once we lifted off, I glanced about me to see if I could spot a likely-looking passenger who might be going to Muscat along with me, but no luck. The plane was half-filled with a Finnish hockey team, but nary a turban to be seen.

The Skyshop catalogue was handed out and as I glanced through it, instead of just drooling, I threw caution to the winds and bought a jar of glorious-sounding face cream which, if used regularly, would turn me into a sexy young siren, at least. The price was almost as amazing as the product! It was a good thing dinner came when it did, to save me from further monetary disaster. It always amazes me when I hear people, especially Alberta farmers, complaining about meals served on planes. I think it must be the times they were raised in which makes them afraid to try anything different. There really weren't too many options during the Depression years – meat, gravy and potatoes if you were lucky, lots of macaroni, and lard sandwiches for school. Not a good hot curry or liver paté in sight. I must admit though, part of the thrill of flying for me is to have meals which I didn't have to prepare and don't have to clear away!

One thing I noticed on that flight – commercials – I thought I had left those home in Canada! I did see a wonderful short film on a doctor in Ghana. It was very much a tourism promo, but the sights and sounds of Africa were wonderful. After a long flight, we arrived one hour late in Frankfurt and I was dismayed to find my connecting flight to Muscat had already left. On inquiring, I learned the next flight to Muscat was in four days! I was expected in Dar es Salaam the next day! In Frankfurt airport, you can walk miles and that's what I did. I finally cornered a suave-looking fellow at the Lufthansa desk and explained my situation in something only slightly less than panic. He finally cut off my tirade with an eloquent wave of his manicured hand.

"Why, my dear lady, are you wanting to go to Muscat?" he snorted, "They don't want or even like women there!" He shook his head as if even speaking of Muscat was slightly distasteful.

"Why don't you just go back to Canada where lovely women are appreciated?"

Well, if I had thought of that, which I certainly hadn't, that last remark of his would have changed my mind post-haste. I

think the poor fellow was trying to be kind, but it had the opposite affect on me and I was going to get to Muscat if I had to walk there! When he saw what Bill calls "that Irish look" on my face, he gave up and got busy on the phone, and succeeded in getting me booked in at the adjoining Sheraton hotel at Air Canada's expense until we could sort things out. By the time I had collected my baggage, had it stored and carried my two-ton purse across the walkway to the hotel, the bloom was off the rose, so to speak, and it would take more than a five-star hotel to bring it back. After much scheming and planning and phoning poor Bill, it was decided the best move was to take a connecting flight to Amsterdam and fly from there directly to Dar es Salaam. This way, I'd only be two days later than anticipated.

Once that headache was settled, I relaxed and had a typical German supper of roast goose, dumplings and red cabbage. I asked the waiter if he was an East Indian, a big mistake I soon found out. With a look of utter disdain he snorted, "Madam, I am Greek!" I think he was so affronted he charged me for my glass of water! I couldn't help but wonder, deep in my cheap soul, why anyone would spend 122 dollars American to stay in a fancy hotel in the first place. Even though the food was good in the medium-priced restaurant, it certainly wasn't fancy enough to match the prices! I furtively stashed my two buns and a pat of butter for my breakfast and went off to sleep quite righteously.

By next morning I was feeling decidedly better. I ate my two buns and off I went to collect my tickets with a jaunty step. Then I went to the very lowest level, where my bags were stored, wanting to get them checked in so I could relax a bit before my flight. I got a cart and walked up to the counter where a jolly fat fellow was working. I asked for my bags and he lifted them out to me, but on taking a second look at me with my shoulder dragging under the weight of my immense purse, he came out and tossed my bags on the cart.

"Come on, my dear!"

He managed – how I'll never know – to actually get the cart on the escalator and up we went to the proper level, where he gave a bow and off he went with a wink.

"Have a great trip!"

Once I had my luggage out of the way, I wandered through the airport, finally settling down to do some serious "people watching," a favorite occupation of mine. Soon a family group came and sat with me. By their look and language, I took them to be Kurds. I tried speaking to them in English, but they just shook their heads and smiled gently at me. I sometimes wish there was just one language universal around the world – it would make living so much more worthwhile and might even eliminate some prejudice. They offered me a drink of bottled water, which I tried to thank them for as they walked off to catch their flight.

The airport, like all airports, was filled with moving humanity, like ants in an ant hill; kids of all sizes playing away without a care in the world, collected now and then by harried parents when they strayed too far; police men and women, staring about, guns in belts; and stewardesses scooting along with their little bags to catch whatever plane they were destined for. Then a group of four men surrounded me. Now these fellows, I couldn't figure out. All grey-headed and rough-looking, very furtive-eyed and ill at ease, wearing tattered old clothes you'd expect to see on a peasant. As I looked at them curiously, they looked away, almost as if afraid. These fellows had me stumped. Then along came a capable-looking younger couple who seemed to be their chaperons! They immediately started handing out a lunch of buns, cheese and hard boiled eggs, which they were carrying in a plastic laundry basket. But nary a word was said. This was strange.

I began to feel a bit like an old rose amongst some strange-looking thorns, so I went for a stroll, hoping to find a clandestine meeting or a drug deal going down, not that I'd know one if I saw it. But what can you expect from someone whose husband had quit smoking for three weeks before she noticed?

Boarding a very small cramped KLM plane, I squished into my seat. Soon a snack of buns and cheese was served by two old war horses of stewardesses, whose very mien said, "Don't mess with me, buddy." All the passengers kept their eyes downcast and not a snicker or a whistle was to be heard. I had forgotten how immense and clean the airport in Amsterdam is – a real metropolis. All the shops with prices so high they would wake up a brain-dead oyster. I didn't even buy a cup of tea; instead I emptied my aspirin bottle into my purse and filled it with water from the rest room. True, I did receive some weird looks from passers-by, but then you see everything in Amsterdam. I tried to cat nap a bit, with my purse under my head and my carry-on wrapped around my ankle, and actually slept for about an hour.

When I finally got to the departure lounge for my flight to Dar, it was absolutely packed. Everyone was either German or Dutch, with just a sprinkling of others, plus a group of young soccer players headed for Malawi. I spotted a young East Indian fellow looking my way, so I gave him a hearty grin and strolled over.

"Do you happen to know anyone in Tabora?" I asked. I spent 2 weeks in Tabora a few years ago and the place is full of East Indians (*From Dar to Zanzibar*).

"You're going to Tabora?" he beamed.

"No, no," I hurriedly corrected, "I just have good friends there!"

The upshot of it was, he knew Lalani, had gone to school with Mumtaz's brothers and had met Azad, her husband. Of course, I knew asking an East Indian if he knows anyone in Tabora is like asking a Schmaltz if he knows Beiseker! I also learned he lives in Toronto, loves Canada and would never live anywhere else. He brought his mother and father out to Toronto, but they missed Tabora and couldn't adjust to our winters – that was no surprise, I even have trouble adjusting to our winters! His father had been a miller, but now was so afflicted with arthritis in his knees he could barely walk. His

dad had been scheduled for knee replacement surgery, but cancelled out, figuring he'd rather face constant pain than go through such an operation. The young man had lost his only brother a year ago and was on his way home for a special service, called *Midlas*, where everyone brings gifts of food, etc., to the mosque in his honor. The gifts are auctioned off afterwards, with proceeds going to the Aga Khan hospitals and schools.

On the flight, I was seated with a petite English lady who owned a little antique shop with a partner, which she enjoyed, especially combing the country for treasures. She had been married for 20 years to a professor who taught at Oxford, had two sons, had been divorced for 11 years and was still enjoying her freedom. But now she wanted a change. There was a new man in her life she had to decide about, and having a friend teaching in Malawi, she felt that would be a wonderful place for a holiday and would give her the space and the time to decide her future.

Landing in Dar at nine next morning, I whizzed through in amazing time and was treated with nothing but courtesy. When I got to customs, a big jovial fellow eyed my four bags, still adorned with orange pom-poms.

"Madam, what have you in those bags!"

I had visions of having to unpack the whole lot, washboard included, and shuddered. I wondered if I should ask if he would help me pack the lot again.

"Presents!" I answered him.

"What kind of presents?"

"Cheap ones!"

He just put a big chalk mark on the suitcase and waved me on with a smile.

"On you go!"

I couldn't believe it. The airport personnel were nothing but kindness and capability. What a wonderful improvement over six years ago, when I was met with infamous discourtesy – things were definitely looking up!

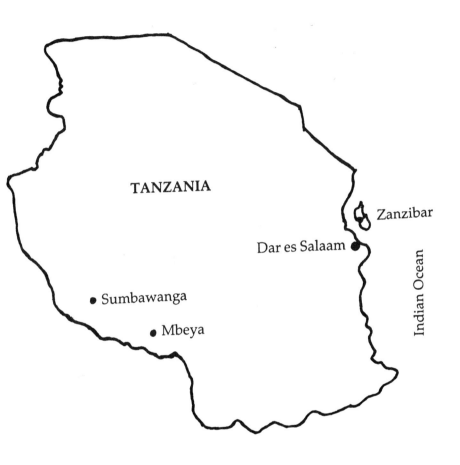

Haven of Peace

My new East Indian friend had people meeting him and he kindly offered to give me a lift to the Flamingo hotel, an Ismaili guest house where Sultan, Yasmin and the boys owned the restaurant and beauty parlor. When I was in Dar in 1989, I had met Sultan and Yasmin and had planned on spending a few days at their home before going up-country to Sumbawanga. When I arrived, I learned that Sultan and Yasmin were on safari in India, where they had taken their youngest boy, Rahim, to see a specialist. But their two older boys, Bobby and Fayez, were holding the fort. After great hugs and greetings, Bobby snapped his fingers and a little African was ordered to take my suitcases the two blocks to their apartment. Knowing how heavy those bags were, I felt terrible, but I needn't have worried; what I could barely lift was hoisted up with disdain onto the curly head and off we went – me sauntering behind like a wrinkled queen.

On arriving at the apartment building, the first thing you notice is the blue door, the only one on the street, which opens into a courtyard surrounded by apartments. The little courtyard is like a small oasis, where you feel safe after jostling through the crowds and hanging on to your purse for dear life. On looking up, you'll see you are tented in by all the washing flapping out of the windows of the various apartments, like so many exotic butterflies flitting about. You have to climb up three flights of stairs with whatever energy you still have left, but it's worth it when you stagger into the Jiwas' apartment.

It's huge compared to other apartments and quite well-appointed and very cosy, with a parrot that talks to you and a big aquarium of huge, slow-moving fish. The dining room, where a lot of time is spent, is big, with two fans working overtime when the power condescends to stay on. A regular living room lies off it, with western style sofas and chairs and a huge TV where Indian videos are watched almost nightly. The three bedrooms have air conditioning, a real blessing in the heat of Dar. The kitchen is very small, with a small stove, sink and cupboard battling for minuscule space. Yasmin hopes to re-model the kitchen, taking out a wall to enlarge it. She has been saving ideas and plans for her "dream kitchen" for several years. A small room holds the African-style toilet, where you have to scrunch over a hole with no support. It's the getting up that got me – if you are planning a trip to Tanzania, you might do a few exercises before going! There is a larger shower room, with a western-style toilet as well, which was in use every hour, it seemed, as everyone wanted a cool shower each time they came home.

Jet lag and I are old adversaries. We know each other well and so far, jet lag wins hands down. Each and every trip I take, I try something a little different, hoping to win at least one round with it, but no luck. I'm an absolute zombie for about a week, but this time was worse as my chronic bronchitis had kicked in with a vengeance. I can control it in dry old Alberta, but in the heat and humidity of Dar, I could feel the virus building like a Hitchcock film. With the first hacking cough, I dragged out my pharmacy and fed myself antibiotics and Buckley's and puffed on my puffer like it was a breath of life. So for the first few days, I sat about recuperating and chatting with the new housegirl – actually chatting was using the term very loosely. I had my old battered Swahili-English dictionary with me and sometimes we understood each other and sometimes not – but with great hilarity and much action we struggled on. I learned she came from Iringa, which was "much nicer than Dar – the weather is *baridi* (cooler)." She said working for Yasmin was "*mzuri sana,*" which I knew meant really good! I found I was still Betty Auntie to the boys – one to be revered or at least respected with great awe. This always

amused me, but I hesitate to say, I think age had a lot to do with it!

I found Fayez, the middle son, who was 14 when I saw him last, had matured and settled down. He had also developed a wonderful continental air about him, even to wearing either blue or green contact lenses, which was amazing, as he has the most beautiful dark brown eyes! He had always loved hairdressing and now had completed a course and was working in his mother's salon. Bobby, the eldest boy, was much the same, quiet, kindly and quite mature compared to Fayez's flights of fancy. He had always dreamed of owning a posh restaurant, but knew his clientèle were working people, so he just tucked his dream away for now and tries to keep the business going, hiring skilled workers and serving good food. They had recently pulled off a major triumph by hiring a marvellous cook from Zaire.

I had written to the family of my plans for the trip and the date of my arrival. On getting my letter, they had immediately phoned their parents in India, so I had a distinct feeling they had been threatened with a fate worse than death if they were anything but helpful to Betty Auntie. Once more, I had to get used to late suppers – at 9 or 10 p.m. after prayers. Breakfast was whenever I got up, cooked by the housegirl whether I wanted it or not, and consisted of bread and *chai* (African tea, which I love. It's a mixture of milk, water, tea and tons of sugar) and the odd time I would have a fried egg. I walked over to the restaurant for lunch each day, where I was served a meal which would do justice to a cross-country trucker. Supper was a repeat of lunch. No other group or nationality are as hospitable as the Ismailis – bar none – they absolutely kill you with kindness, stuffing your body until you waddle, filling your head with wondrous lies about how talented, important and precious you are. Everyone should have an Ismaili family to go to for therapy for depression or insecurity.

Even with all the kindness the boys were showing me, I distinctly felt that old dreaded feeling I always get for a day or two when travelling.

"What on earth ever possessed me to come on this trip? I'll never make it – I'll just lie here and die and Bill won't bother sending for my body!"

I sometimes think it's a good thing Africa is slow – if I could have flown home those first two days, I might just have done so – never had I been so sick with bronchitis and I had forgotten how very hot Dar is in January. The rains had not arrived, so the desperate heat continued unabated. When I stepped outside the sun was hot enough to melt the marrow in my bones. It's little wonder the colonials went to such lengths to protect themselves when going out. I remember reading that white women used to wear spinal pads made of horsehair to prevent heat prostration, which they thought could melt the spine! I think the preventive would be worse than the heat!

Early in the mornings, I'd go with Filo, the housegirl, to the market. I love markets of any kind with great passion. The colors, smells and sounds are mesmerizing. It doesn't matter if I'm buying – I just love walking around soaking in the atmosphere like Chanel No. 5, although I've got to admit the meat and fish stalls *do not* smell like Chanel No. 5! This market was brimming with goods and humanity. Mounds of rice, flour, all types and colors of beans and every other imaginable vegetable and fruit. I couldn't help but think back to my old Sumbawanga days – I had carrots only once in two years!

There are always home remedies consisting of heaven-knows-what for sale in markets, and Dar was no exception. Little bottles of liquid, roots and even big boluses. I noticed the signs on two of these remedies. One, *Akazi Os Balk*, had a sign underneath which read, "If a woman is faulting to get children this is a strong medicine to birth children. When using it everything will come automatically and reproduction will be essential!" Another one, called *Mankwala Ochisa Coica Shimenepaaku*, means "This will prevent a person trying to kill you by letting you eat poisonous foods." Yes, you learn a lot in an African market!

One day I walked to the post office to mail a letter to Bill. I wanted to send it express post, as it ordinarily takes three weeks to get a letter from Dar and I would be home before the thing actually got there. The postal clerk was a friendly chap with a soft smile. I was the only *mzungu* in the place and I was the center of attention, as people started milling about me. The clerk said the letter would indeed be sped on its way immediately. Curious, he asked me where I was from, why I was here and why anyone in their right mind would actually want to go to Sumbawanga unless ordered to! I noticed his double take on reading my return address: from Betty Kilgour, Darkest Africa. I imagine he felt anyone weird enough to use such a return address belonged out in Sumbawanga country. I was having trouble actually getting to Sumbawanga – it being the holiday season, all offices were closed, so I had to relax a bit before I could try to get a flight to Sumbawanga.

When I first met Yasmin, she was taking a hairdressing course, which she completed, and had opened a shop beside their restaurant in the Flamingo hotel. I was very keen to visit this establishment and see how it was operating. So I popped in and was surprised to see 7 stylists working. Some were part-time and others were apprenticing, but all of them were going flat out and even turning customers away. I heard that New Year's Eve is the busiest time, even in Darkest Africa.

One customer you couldn't help but notice was a beautiful Arab girl who was preparing for her wedding, loaded with 24K gold rings, bracelets and earrings. She had already had the famous scroll painting finished, not just hands and feet, but up to her knees and elbows. The hairdo being created was not a plain blow-dry job, but an intricate mix of curls of all sizes, hanging every which way, and hennaed to a beautiful rust color. Oh my, she was a gorgeous creature!

Then I ducked in the entryway to the hotel, which is really a guest house for Ismailis when they visit Dar from up-country. I wanted to see little Salum, whom I met on my last visit. He was far more than a night watchman, which is what he got paid for. No, he was a roving ambassador, a statesman for all

who entered his domain. Nothing happened at the Flamingo that he didn't know about and he was continually keeping the hotel running smoothly as he walked the courtyard and halls. But I was sad to hear that Salum had retired to his village on the outskirts of Dar and the Flamingo was poorer for his going. But the cashew baggers were still there in the corner of the courtyard, weighing and sealing cashew nuts over their small homemade flames.

On returning to the apartment, I was just in time to meet a young man who was to sing at the mosque that evening. He was rather an effeminate-looking fellow, with artificial-looking streaked hair, but with the loveliest smile. Even the very cosmopolitan Fayez was duly impressed.

"Betty Auntie, my friend is a very famous singer in Tanzania – you must come and hear him tonight!" But alas, I knew, being a white Presbyterian, I wouldn't be able to go to the service at the mosque; besides, with my bronchial cough, I would totally disrupt even Pavarotti! So I wished him well and told him to send me his first tape.

Then Fayez's uncle came along, wondering why I hadn't visited his new home. He had recently married a slightly older widow, a little short chatter-box loaded with baubles and beads. I remembered the fellow as a rather sad lonely individual, but his marriage had changed all that, and now he was much more self-assured and easy to chat with. The whole Ismaili community can hang a guilt trip on me without even trying, so when he asked why I never called on them, in such a sad, heart-jerking tone, it made me feel utterly callous for having caused them such pain, it was not surprising that Fayez and I strolled over there the very next day.

I thought it would be a good chance to try and phone the Moravian Mission in Sumbawanga, so they could let the Kilangala staff know when to expect me. After chatting a bit over *chai* and biscuits, we proceeded to try to get through. No one in the Western world can know what a palaver it is trying to phone upcountry in Tanzania. Finally, after trying for over an hour, I got through and tried to explain who I was and what

I was phoning about. But the man on the other end just couldn't understand me.

"Pardon – Pardon me?" he kept asking and I'd go into my story yet again. Finally, in desperation I believe, he stated quite huffily, "Madam, can you not speak English? I mean Proper English?" I gathered that my Canadian English was not Proper. Finally, in desperation, Fayez took over and told him I was in the country and when I could possibly arrive there, even though we weren't at all sure as yet when that would be.

On our walk back home, I noticed how Dar had changed. When we lived in Tanzania, very few people had cars, but now the streets were lined with them. Fayez said many families have two or three cars. You can also buy anything you want in Dar, if you have the money. It definitely was much more a metropolis now, with a strong western influence everywhere. Most main roads are well maintained and the Japanese built a beautiful main road around Dar, as they have vested interests in Dar. I don't blame them – Dar is a special place. Dar es Salaam, meaning Haven of Peace, started out as a humble fishing village in the 19th century. Then the Sultan of Zanzibar decided to turn the inland creek the village sat by into a safe port. This is now the harbor in Dar es Salaam and the small village now the largest city in Tanzania. It became the Capital in 1891, when the German Colonial authorities transferred the seat from Bagamoya, because the port there was unsuitable for steamships. Now a city of over 1½ million people, there are a few high-rises in the city center, but the suburbs remain substantially a low-rise city of red-tiled roofs, with colonial character still intact. The harbor, so picturesque with palm trees and mangroves, Arab dhows and dugout canoes, is possibly the nicest anywhere.

That evening we watched the uncle's wedding video, which was a good three hours long. The whole wedding affair took about three days, consisting of many pre-wedding parties and customs, some at the groom's home and some the bride's. Both the bride's and the groom's family give gifts of jewellery and silk saris to the various women of each family. The mothers

and grandmothers would receive the most and so on down the line.

They have a unique party which replaces our stag night. The groom-to-be, attired in only shorts, sits on a stool, which is surrounded with newspaper to save the rug. Then each guest takes a raw egg and breaks it on the poor fellow and rubs it in; no place is sacred from head to toe. I saw one video where each person gave a small gift of money for this honor, but it started slightly more sedately, with chick pea flour mixed with egg, and only a small anointing was the style. It's their way of having fun without a big liquor bash like some held in western countries.

No pictures are allowed in the mosque during the wedding, but there's ample opportunity before and after. They also have another tradition which is slightly different. All guests leave their shoes at the door of the mosque when going in for the actual ceremony, and when they try to leave, a sister-in-law or a cousin will steal the groom's shoes and demand a ransom. It's usually money and they will barter back and forth until they agree upon an amount.

The first working day after the New Year, Fayez phoned Air Tanzania and found, to my dismay, that they no longer flew out to Sumbawanga, now going only as far as Tabora. The only alternative route was by Tazara railway as far as Mbeya, which I knew I could handle, and then by bus to Sumbawanga, which I wasn't so sure of. This trip was not for the faint-hearted. I had travelled it many times when meeting Beth and knew every bump on the tortuous route (*So This is Africa!*). Every three months, I would either be meeting Beth or sending her off and this entailed four trips by bus each time. I still have callouses! I would get on the bus at 7 a.m. in Sumbawanga and many times it would break down en route and we'd be on the bus overnight. When we came to high hills, all the passengers would have to get off and walk up and the poor gutless wonder of a bus would hobble up after us. If we got into Mbeya by midnight, it was considered a great trip and, considering this was only a 200-mile trip, it seemed slow. Keep

in mind that most of the world is not blessed with roads like in Canada, and there is only about 500 miles of hard surface in all of Tanzania. The rest are victims of weather and poverty. The buses were in very poor condition as well, so I was not looking forward to this trip.

That night, still suffering from jet lag and bronchitis, I went off to bed with a black lump in my heart, muttering insane things.

"I'll just stay here in this bed until my return flight is due and go home and never travel again."

I then, as I always do when I'm beat, physically and mentally, after trying to solve a problem and making it ten times worse, called on God. Now, I have always had a deep faith in God – even as a little girl – but I also have some sort of a mechanism built in that figures "I'll solve this little problem myself – no sense in taking Him from His majestic running of the Universe." Then, when I mess up royally and make things fifty times worse, I come crawling to Him. I sometimes imagine, when yet another of my tear-soaked pleas for help reaches His throne, He turns to whoever and shakes his head, muttering, "Not her again!"

This time I snuffled out my worries and promptly fell asleep. Then a strange thing happened. I awoke in the middle of the night, my mind clear as a bell and found myself out in the dining room, notebook in hand. I felt absolutely refreshed as I sat there making a list of what I would need for my trip – all thought of staying in Dar was completely gone. My immediate thought was, "I'm looking forward to this trip!" and my second thought was, "Boy, God can really move when I'm out of His way!"

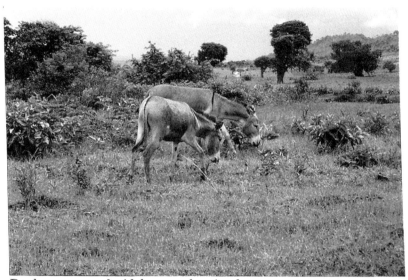

Donkeys are used widely as pack animals.

Another Scenic Route

I felt absolutely wonderful the next morning and I greeted the boys with a big grin.

"Hey, this trip will be a piece of cake – can you purchase my ticket for me please, Fayez?"

Some very strange looks passed between the boys, I can tell you. I think they figured I had O.D.'d on my malarial pills! I knew enough to arrive at the station early, as it takes time for the long line to disperse. Mamas in brilliant *kangas*, standing in line, pushing their assorted baskets and boxes along with their feet – not a suitcase in sight, laughing children running about and men talking in small groups. I had forgotten the sights, sounds and smells of an African train depot – especially the latrines! Of course, in such a hot, humid climate, it would be impossible to eliminate those particular smells.

One thing I absolutely abhor is corruption of people in power. Each passenger had to go through a small office, where a uniformed man was checking papers. My Swahili being practically nil, I was having a problem figuring out the heated conversation Fayez was having with this man. But one phrase I did figure out made me gasp.

"But she's a very old lady!" Fayez pleaded. The fellow glanced my way.

"Leave the room, Madam!"

I knew full well what was going on – he was ordering us to pay extra under the table or he wouldn't stamp my passport, which would allow me to board. Isn't it strange, when most of us are confronted with someone in power who could change our plans, we panic. I wanted to stand up and say "No, I'm the one who's travelling and you are not going to blackmail me," but I wanted to get on that train and Fayez had to settle for nearly double the ticket price. There is still some bribery and corruption in Tanzania, and what the answer is I'm not sure. Possibly there should be a decent raise in wages for all government workers – at airports, police stations, train stations – everyone in a position of power. Then an absolute clamp-down, allowing absolutely no graft or corruption. Those who get caught, get jailed and fired. Corruption is everywhere, I know, no country is free of it, but it still doesn't make it palatable for travellers. It was such a relief to finally board and find my compartment. It contained six bunks and I immediately grabbed a bottom bunk and collapsed.

My travelling companions were varied. One young Tanzanian Mama, holding a four-month-old baby, was accompanied by a younger brother who looked to be ten or so. All were extremely shy, only smiling as they left the train at a little station in the middle of nowhere. All three were spanking clean with crisply-pressed clothes, but the baby outshone all of us. We were still in the heat belt, but that baby was bundled up for -20 C. Pink eyelet dress with blue swan embroidery, blue check plastic pants, orange crocheted socks on little feet tucked into pink and white boots decorated with a little face which squeaked when touched. This African trio travelled with just one basket filled to the brim and two loaves of bread, which were hung on the wall.

Besides this group, there two young white women, one, an English girl originally from South Africa, and the other, a Norwegian. They were typical back-packers, faded clothes, big hiking boots, with utilitarian grey socks rolled over the top. No make-up on their sun bronzed faces – the only concession to decoration were the rings on every finger. The way they were chatting, I figured they were travelling together, but

no, they had only met on the train. Each one was travelling with her boyfriend. I had forgotten men and women are not allowed in the same compartment – not even married couples – unless they buy all the tickets for that compartment. Another tall, slender African lady was aided in by her husband, who settled her big bags in the carrier and checked us all over to see if his wife was safe with us. She was from South Zambia and she frowned on Dar, where she had gone for shopping, and was so glad to be returning home. Dar was too hot, not friendly and the Swahili spoken there was inferior. On that sad note, she crawled into a top bunk and slept the rest of the way with nary a sound but the odd snore.

We left Dar about six p.m. and would arrive in Mbeya at 11 a.m. the next day. The first part of the journey was through a lightly-wooded area with little mud huts scattered here and there, smoke filtering through the trees. As the supper gong went, I opened the huge bag Fayez and Bobby had packed for me. Well, I thought, they must think I'm starving as well as ancient! What an array of food! Certainly enough for six trips and all delicious. After I settled back, lulled into peacefulness by the music of the rails, I mused about many inconsequential things, but my reverie was broken when a familiar scent wafted my way – what was it? I knew it well, but it eluded me. Then I sat bolt upright – Estee Lauder Youth Dew!! I had to be imagining it – how could one of my very favorite scents be drifting by on a train bound for Mbeya? But, no, there it was. I'd know that fragrance anywhere! I was right, too, as a huge Tanzanian Mama swept into our cubicle, Youth Dew and all.

We stopped at every little whistle stop along the way and I loved the view of each little station, but one of the ladies warned me, "Watch your bags – thieves often jump through the corridor windows and grab your bag and are gone before you can even yell for help!" I hated always having to worry about thieves, but realized it was the same in every country, even Canada, and I refused to become a victim. I went off to sleep after taking a Gravol for train sickness and didn't hear a thing until I awoke refreshed in the morning.

At all the whistle stops, young boys would appear from every angle, glancing left and right, selling little packages of groundnuts and bananas, only to scatter like geese when an armed guard appeared. The second he walked by, they crept back out of crevices and cracks and tried once more to sell their wares.

By now we were in the mountainous region of Mbeya, a beautiful sight filtering through the early morning mist. The villagers were out full-force, working in their *shambas*. Many were using oxen, one man even ploughing with six at a time, while another fellow broadcast seed on the newly-ploughed land. What amazed me was the fact there were far more men than women working the *shambas*. I saw only one very basic tractor being used, but I saw groundnuts already up and growing in many plots. Groundnuts, by the way, were imported into East Africa in the 16th century and now play a very important role in the economy of Tanzania. I learned the rains had also been late in this area, having arrived only a few days earlier. It was a great trip and one I enjoyed thoroughly. The train was on time and quite comfortable.

Actually Tazara rail is an excellent way to travel when in Tanzania. Maybe not to some westerners, but I have always enjoyed travelling on it. This line was built by the Chinese in the 1960s and passes through some of the most remote country in Africa, including the Selous game reserve. Building the line involved the construction of 147 stations, more than 300 bridges and 23 tunnels. It was beautifully maintained while the Chinese were in charge, but now has slipped a bit, with the service slightly more erratic.

We arrived right on time, my young friends fussing over me, carrying my suitcase (I wanted to ask them to carry my purse, as it was heavier), asking if I was being met, and if I'd be okay alone. I didn't want to be rude, so I just held back and seriously assured them I was just fine indeed and well in control. I can't get over how odd everyone thinks it is to see a white woman travelling alone in Africa.

I caught a taxi – or rather he caught me as I stepped from the train – and I told him I wanted to go to the Mbeya Railway hotel. As we drove into the city, I wondered if the place would have changed in the 20 years since I last saw it. Back then, the Mbeya hotel was a warm oasis for me, when I arrived battered and bruised from the punishing bus trip from Sumbawanga. Ninety percent of the time, I was the only *mzungu* staying there, so it was little wonder the staff remembered me, and I was the Mama from Sumbawanga to not only the staff, but practically all the taxi drivers I met. As we drove up, I felt like I had stepped back in time. There it was, squat and welcoming, the gardeners working away, the bushes in full bloom, the walkways and dining room as I had left them so long ago.

The Mbeya hotel was a railway hotel at one time, owned by the government, and still had some of the trappings of colonial times. It was more a motel than hotel, with guests entrenched in small cottages to the rear of it. I had hoped some of the same workers would still be there, but it was a vain thought. Twenty years is a long time. The 26 dollars a night was quite reasonable and the room was clean, with hot water and loads of character. Still in my time warp, I ate the same type of food at the same little tables – white linen and silver with the waiters in white jackets. I'm never one to be fashionably late for my supper, so when I entered the dining room, there were only three people. One was an American with two Tanzanians. I pinpointed the white man as a Texan, by the accent and patronizing way he had about him.

The next morning, I awoke from a very sound sleep to a tap on my door. Oh heavens, I had forgotten about the 5:30 *chai* ritual! Each morning, unless you leave word you do not wish to be disturbed, you are brought piping hot tea. My day had begun. I called a taxi, wanting to go and buy a bus ticket for Sumbawanga early to ensure a good seat, and I also had the address of Sultan's sister, who ran a business in Mbeya. I had promised Fayez I would look her up.

Once downtown, I wandered about trying to find her. I knew they owned a video rental shop and didn't anticipate

any problem. After all, how many of those could there be? But at each shop I inquired, I was met with vacant stares. Even the name and address I had carefully written down didn't help. This seemed strange to me – everyone knows everyone in the East Indian community. But at one store, I realized what the problem was. One gentleman asked me, "But, Madam, are they Hindu or Ismaili?" Ismailis and Hindus are very differnt religions and do not mix together, so they rarely know each other. Ferial Rajan was Ismaili! I finally ended up in a small bookstore.

"I wonder if you can help me," I asked, "I'm looking for a family who run a video store, whose name is Rajan."

"No, I'm sorry, I do not know those people," the clerk answered, "but possibly this gentleman can help you," as she pointed out an elderly man reading at a corner table. Oh, he was beautiful – great creased face, like a map of life, soft dark eyes – he exuded quiet dignity. I introduced myself and learned his name was Elias Brown and he was a retired policeman.

"Of course, I will try and help you," he said gently. "Tell me, are your friends Asian?"

"Yes, they are Ismaili."

"Well, let us start our search!" and off we went together. We stopped at various shops with no luck, but this didn't bother me overmuch. Even if I didn't find them, it had been worth the search just meeting this man, I was so drawn to him. Finally we stepped into a store where a large woman was sorting greens on her desk.

"Why yes, Ferial is a good friend of mine," she said as she pointed out the store. Part of me wished I could just stay shuffling along with the gentleman, but he took me in and introduced me, which must have been difficult, as he didn't know either of us. He bade me goodbye and left. I was received in a fashion the Ismaili community is famous for. I learned Fayez had phoned as soon as I was on the train and Ferial had sent her husband down to the train station to meet

me, but not having a clue what he was looking for, he missed me. Besides, he hadn't expected someone so *old*!

"What is with these people?" I thought.

Ferial was absolutely stunning, with lustrous long dark hair and cheek bones to kill for. It wasn't long before I found myself in their home having lunch. Eating three kinds of curry, *chapattis* and salad, I raved about the food. Ferial said their chef was the best in all Mbeya – every other woman wanted to steal him. He started out working for the Rajans as a very young houseboy and now his hair is sprinkled with silver.

After a delicious lunch, we walked uptown looking for postcards with an African motif, but with no luck. All the available ones had either English pastoral scenes or roses, which are popular with the locals. Going back to the Rajans' video shop, I addressed and stamped them, as I wanted them off in the mail before I left Mbeya. I then phoned Sumbawanga with the time I'd be arriving and the bus I'd be on. Feeling that I had accomplished everything I could to help me with the dreaded bus ride, I sat back content. Ferial was concerned about my bronchial cough, which by now made me sound like a sick warthog, so she mixed up a drink of special spices to help soothe it, but the look she gave me left me to believe she thought I'd expire before I ever returned. I was just thankful she hadn't heard it a week ago.

For the rest of the afternoon, I sat visiting with the customers who arrived regularly at the shop. One was a dapper little tailor, who popped in with a skirt for a daughter's school uniform. He was very proud of his work, showing me a new design he had created so the pleats always hung straight. I complimented him on his expertise, remembering the trouble I had had with pleats, and he gallantly stated, "Madam, you yourself must be a great seamstress to recognize such fine work!" I left that alone, thinking I could never improve on that remark!

On returning to the hotel, the gardener, a cute little boy, led me through the flower beds, explaining what he was trying to

create and how the various shrubs and flowers were doing. He even had created the word *KARIBU* (welcome or come in) out of miniature plants, so every guest would feel welcome. I thanked him for the tour and gave him one of the caps decorated with oil rigs and such my son had given me for just such occasions. This small act caused such a stir, I ended up passing out the rest of them. No one who hasn't seen how excited Africans can get could possibly understand the commotion – oohs and aahs, interspersed with much hand slapping, the odd trill and even a dance step or two. After they all left, I felt like I had been through a wind tunnel.

After supper, I ordered a box lunch and two Fantas from the chef for my trip the next day, and after re-packing and showering, I fell into my bed. What a day it had been. I was too excited to sleep as I lay there musing, I was actually going to see Sumbawanga the next day, I would finally see Kilangala Mission and some of the people I had known 20 years ago – in some ways it was a scary thought. Would they be disappointed? Would I? I finally fell asleep, knowing I'd need all my strength for that bus trip.

The next morning I was up before my *chai* arrived and was ready, waiting for the taxi I had asked to pick me up. All the taxis are decrepit, with broken side windows, springs poking through the upholstery, and door and window handles missing, but the cabbies are a jolly, madcap bunch who cheer even the dourest person. My guy arrived right on time and chucked my bags in with a flip and off I went with "good luck, Mama" ringing in my ears. But their good lucks weren't enough. About halfway to the station, we ran out of gas. The poor driver had to ask for some shillings, as he grabbed the jerry can and went running down the street.

"Oh," I thought, "I'll never seen him again!" But soon he came running back, poured in the gas, and with a great lurch, off we flew, getting to the bus depot with seven minutes to spare. He grabbed my luggage and tossed it up to a man on the top of the bus, who settled it in to brave whatever elements we would face on our trip. That is why I always advise people

to take their oldest, most decrepit luggage on a safari to Africa. Next, he almost carried me to my seat at the front. But just before the bus took off, a little Tanzanian came on, looked at me and my seat number, and started jabbering ninety miles an hour in Swahili.

"Oh," I thought, as I checked my ticket stub, but I was in the right seat. I couldn't understand the Swahili blowing about me as other passengers took up the cause – which I didn't understand. Finally, I stood up, preparing to move to another seat, but the driver turned about and said, "*Humna Tabu Mama* – okay-okay!" So I settled back down, with the little man in the seat across from me. I was pleased to see the bus seemed to be well-maintained – even the springs seemed to work! I knew we'd be leaving the hardtop in three hours and we'd need all the springs it had.

"I can handle 12 or so hours on this bus!" I comforted myself as the African scenery swept by. It was good to see the Mbeya landscape again, as I recognized some landmarks.

As we drove along, I noticed the grass was greening up and many trees and shrubs were blooming, sure signs the rains had finally arrived. As I relaxed, I noticed my sense of smell, which had been missing for two weeks, was returning – I could even smell my own cologne – nice, but not remarkable, my kids would say, since I'm so extravagant with it. It was nice to be travelling comparatively light, as I had left my big suitcase in Dar, but my purse was even heavier. Many of the huts sitting among the trees were now made of homemade brick, some even sporting chimneys. Many Mamas out in their yards waved, as every child did. The passengers often shouted greetings out the window. I was surprised to see so many donkeys being used as pack animals – this was certainly new. The trip was taking on a carnival atmosphere as passengers loosened up, chatting away, laughing and slapping palms.

We arrived in Tunduma, the end of the hardtop, by an amazing 9 a.m.! Could it be? Now came the test. But I felt secure I could handle another 11 hours, as the bus was so comfortable. All sorts of goods were being sold by boys,

holding their trays aloft. Hair oil, soap, Colgate toothpaste? What was this country coming to? I didn't see Colgate the whole two years we lived here! Biscuits and fruit and the little newspaper-wrapped packages of groundnuts. I couldn't absorb it all.

Once on the road again, we turned a corner and a spectacular view caught my eye. Before leaving home I had watched a film, *Zulu*, and this view reminded me of one scene in the movie, where thousands of Zulu warriors lined the top of an entire hillside. I had to blink twice before the Zulus reverted back to what they really were, Acacia trees. But, oh, they had looked like the regiments of Impis poised to roar down on the defenceless British Battalion below!

We weren't too far along before I realized we were on a new road. As we drove along, I noticed this road was not like most Tanzanian roads, In fact, this one looked like a Canadian road. I shook my head – this can't be – but sure enough, on quizzing the bus driver, I learned this was a new road built and designed by a Canadian engineer, paid for by Canadian funds!

The farther west we drove, the poorer and dryer the landscape became. The soil was dry and dusty looking, taking on a moonscape appearance. Stop after stop, belching out passengers and taking others on. I sat back thinking, what a cushy trip, but stopped, realizing this trip would be anything but cushy to a lot of my pampered friends. To them it would be horrendous. Everything is relative – even with travel. But I found myself actually enjoying the trip. The driver was playing his African cassettes, belting out tunes I hadn't heard in 20 years. A big garrulous Mama in a huge tent dress sat down near me, with a grin that threatened to swallow me up.

"Hello Mama, are you a Christian?" she said loudly.

"Why yes, why do you ask?" I replied with an equally big grin.

"I thought so, what do you think of this?"

She handed me a booklet printed in the States, the *Evangelistic Preaching Guide*. By the time we got to our next stop, she had the whole bus belting out "Shall We Gather At The River," clapping in time.

We were soon going through an area where the soil was red; so red, it brought back memories of the soles of my feet being dyed that same red from the Sumbawanga soil; so much so I had to resort to bleach to lighten them when we came home to Alberta. Passing one village, I noticed a thatched cross on the roof of a mud hut – a village church, I knew – I had worshipped in them before. We passed herds of long-horned cattle grazing, with many black and white stork-like birds walking among their feet, pecking away. Before I realized how close we were, we were driving up the main road into Sumbawanga! In 8 hours? I couldn't believe it.

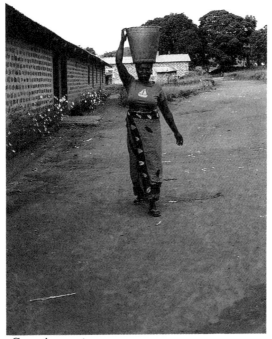

Carrying water.

God Helps Those Who Help Themselves

I was just a bit nervous as we pulled to a stop by the market place. On glancing out the window, I spotted a man I knew well – I'd recognize that grin anywhere! As I grabbed my huge purse and turned about, a snappily-dressed young man came up beside me.

"Mama, this is the third day we have come to town for you, where have you been? I am Moses!"

"But didn't you get my phone message from Mbeya?" I asked.

"No, we have had no phone messages, only your letter from Canada telling of your arrival in Dar; then we just figured it out!"

I couldn't help but think it was better before phones came to Tanzania and all messages were sent by drumbeat! With the initial greetings over with, we went for *chai* in a small restaurant run by an Ismaili.

"*Chai* and *somosis* – food made in heaven!" I thought.

As we chatted, I realized I had one major mix-up on my hands. I thought the big man with the great grin was called Joseph, but instead he was Johnson. This wouldn't have mattered too much, except I had been corresponding with Johnson all these years thinking his name was Joseph! But I was duly forgiven amidst much gaiety and laughter at my expense as

we drove the last 30 km to Kilangala Mission. I soon realized this piece of road hadn't changed as we bumped and swerved, trying to miss the worst of the potholes. By the time we got to the mission, it was late afternoon and although I felt great, I knew I was going on adrenalin only, so after supper at Johnson and Roza's, I was escorted to the little cottage which would be my sleeping quarters while at Kilangala. Darkness had arrived quickly as it does in Africa, almost like an iron blind being dropped from heaven, turning the surrounding countryside into complete blackness in a few seconds. So a lantern was lit to guide our steps to my house.

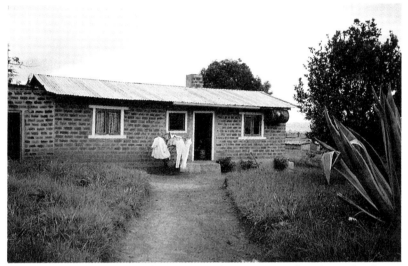

Little guest house used by Betty Kilgour. Note the thorn bush clothes line.

As I stepped into the cottage, which is used for foreign guests, I immediately slipped back in time – a feeling I was to have many times during my stay. The little cottage was basic, clean and cosy. The small front room held the same basic furniture I had had in my house at the ranch and which is duplicated throughout East Africa. The fireplace, although much smaller, had identical tiles to my old one. The small bathroom had a flush toilet, no less, so I didn't have to use an outdoor one, which I had on many other safaris. The ceiling

of the house was made of woven mats securely tied and each night I heard little footsteps racing around above it – what they were, I didn't really want to know. I was totally astounded, though, when I stepped into the tiny bedroom. True, the closet was miniature and the bed just a cot, but covering it was the most beautiful crocheted bedspread I had ever laid my eyes on. Pure white with an intricate design, it had been Roza's grandmother's.

"Oh my, I'd better dust my feet before retiring under that beauty!" I thought to myself.

The one thing I must do each night, in order to fall asleep, is to read for a bit. I had brought only 3 books, so the whole time at Kilangala I was scrounging for books written in English, which were few and far between. In fact, I ended up reading the whole New Testament in two weeks – not something I'd recommend for anyone but the stout of heart! As I snuggled down in my cozy bed that first night, I heaved a sigh of relief and satisfaction. I had travelled from Alberta to Europe to Dar and had crossed Tanzania with only minor glitches – needless to say, a sleepy "Thank you" was sent heavenward as I drifted off to sleep.

Kilangala, a relatively young mission station, was started by a Dutch missionary nurse, Katalina Beimers. As a young woman in Holland, after completing her nursing and bible school training, she decided to dedicate her life to serving God in a foreign mission. Her first thought was India, but I gather God had other plans for her, because her final calling was to Africa, serving at the Livingstone Memorial, a fledgling mission at Tatanda, near the Zambian border. This station had been started by Reverend and Mrs. Deming, a missionary couple from the United States.

In order to raise enough funds for the fare, Miss Beimers tossed her uniform aside for a bit and went out and dug potatoes for the farmers in her district of Holland. I love that story – God helps those who help themselves! On arriving at Tatanda, she immediately took over all medical work, freeing the Demings for the church and evangelical duties. They lived

in grass huts for the first year or two, until more permanent houses could be erected. As time went on and the new station flourished, Miss Beimers realized the desperate need for more mission stations. The villagers all across the Wafipo plateau were in great need of help, with no one to turn to. So it seemed only natural that, after a few years at Tatanda, Miss Beimers took her much-earned leave, going back to Holland for a year to raise the necessary funding. On returning to Tanzania, she built a new mission some 20 miles out of Sumbawanga, nestling it in the Kilangala hills, from whence came the name.

Miss Beimers had adopted three young Tanzanian orphans from three separate families and these she home taught, only sending them to her homeland for their High Schooling and further education. She also saw great potential in another young man from Tatanda, sending him home to Holland for studies as well. All these decisions were to play an important role in the future. In 1967, Kilangala opened its doors and heart to those in need, with Miss Beimers at the helm. A young Dutch doctor and his wife, Harry and Tina Kamstra, ran the hospital efficiently. In 1977 Roza, Miss Beimer's daughter, and Johnson Simgala, the young man Miss Beimers had such faith in, were married and took over the management of Kilangala, leaving Miss Beimers free to pursue her dream of building another mission, Katembo, near Mbeya. In 1978, the Kamstras left for Holland on furlough, later returning to another station in Tanzania. Unfortunately, just a year or so before my trip, Dr. Harry was a passenger in a small plane, flying to Bukoba. It is a common practice for planes to drop parcels at various missions on the flight path, but the Canadian pilot, who had flown low to make an effective drop, found he couldn't get the nose to lift and hit a tree – both men were killed instantly.

I was up early the next morning, with great plans for my stay. It was a typical Sumbawanga morning, bright and sunny with the ever-present wind I remembered well. This wind is not unlike the winds blowing continually at Pincher Creek and Lethbridge, day and night. To my great chagrin, I had actually forgotten how cold it could be – at the ranch we were over 7 000 feet above sea level and with that Rift Valley wind,

I was cold far more than I was hot. In fact, I wore pantsuits and had my fireplace going nearly every day. I soon realized I hadn't brought enough warm clothing and ended up wearing Roza's sweaters the whole time I was there. My water supply was just a few feet from my door at a tap, where the ladies gathered each day to wash their clothes. I noticed how very white the shirts and uniforms were and learned they all use blueing – heavens, I remember my mother using Reckitts blueing! As we ate breakfast, I remarked on how brown the landscape was, strange indeed for the middle of the rainy season, November to March. But I soon learned why – the rains never arrived in November. In fact, as yet they had had no rain whatever.

"The winds have been so strong they have blown the rain clouds away each time they formed!" Roza said, concern in her voice.

"What on earth is going to happen?" I asked in dismay, "What will the villagers eat?" I knew the villagers in that region were very poor and lived completely on their maize patch. No rain would be disastrous.

"I know," said Johnson, "And even if the rains come now, it will be too late to plant maize. Of course, they can still grow millet and beans and possibly wheat, if the rains arrive soon."

"And Betty, we bought what extra maize we could for emergencies – but, oh, we need rain!"

I couldn't help but think farmers are the same world wide – we depend on the weather.

After breakfast, as I was meeting a few of Johnson and Roza's 6 children, all lovely bright-eyed kids, I noticed an older lady helping out in the background. I was told she was Johnson's sister Jinise, who had arrived about a year ago for medical treatment, but was soon going home. She spoke mainly her tribal language, but we still managed to communicate and I thoroughly enjoyed the times we'd be in hysterics trying to get points across to each other. Roza and Johnson were raising four of Johnson's nieces, since their mother

passed away. These girls were older than their children, two already on their own and two teenagers. This is a good illustration of the "extended family" tradition which is so common in Africa.

I spent that first day walking about, getting the feel of the place, amazed I felt so well-rested. My bronchitis had almost disappeared in the much higher altitude. And glory be, that very night it rained and it continued to rain some each day I was there! Usually the mornings were clear, but by noon the clouds would be gathering and rain would fall by evening, sometimes all night. There were several severe thunder storms and I saw more lightning during my stay at the mission than I had the whole two years we lived there. What a difference that rain made! The whole atmosphere changed, big smiles replaced worried frowns. You can't imagine how green the African countryside can become overnight. Shades of green you've never seen, emeralds, olives, rich deep green, as if nature, starved for the sight of green, let her imagination run riot. Where there was just dry, burnt savannah, now it was a riot of color. Carpets of every delicate shade and bushes of mind-boggling beauty when all the flowers of Africa burst forth. The people were all out in their *shambas*, industriously clearing the way for the planting. Hope was restored.

The mission owns 400 acres from which they raise enough grain for the two orphanages, but their dream is to become self-sufficient, raising chickens, pigs, goats, etc., as well as more grain, but they need a basic tractor and other farm equipment to accomplish this goal. This year, for the first time, they planted sunflowers, hoping to raise enough to provide cooking oil for people, which if all goes well, could also be a money maker.

The first place I visited at Kilangala was the medical center. I remember coming for medical attention, when we lived near Sumbawanga, and was so thankful it was available. The hospital in use now is new. I attended its grand opening in 1977 and what a gala affair that was! Members of Nyerere's government were there, as were the police chief from town, many

neighboring mission representatives, Catholic sisters and priests, as well as odds and ends like myself. There were many speeches and tons of food. It was to this center I came when I had a cast taken off my broken ankle, and it was here I came when I needed to learn very quickly how to deliver a baby if the need arose (*So This Is Africa!*).

Through the ensuing years, I kept in touch with the various doctors, as I had a keen interest in the hospital. The last doctor they had, Oswald Sipemba, was a great correspondent and we worked together for several years. I was horrified to receive the news, 3 years ago, that he had passed away – this special human being, who devoted his life to helping the sick, succumbed to the scourge of Africa, AIDS. My dream during those years was to return to Kilangala and meet the man, so it was with bittersweet feelings I met the new doctor, Dr. Festo Michael Msasa, a slight, handsome fellow with a gentle manner about him, who had just arrived in October. I have great trouble recognizing even the basic tribes in Tanzania and thought he must be from the Chagga tribe – but no, he was of the Mha tribe from the Kigoma region. He took his secondary education in Kigoma, going on to take a Medical Assistant course at an MA Center in the Morogoro region. He worked in the Government hospital in Sumbawanga before being posted to Kilangala.

When a doctor is needed, the mission applies to the government in Dar and they pick a doctor who fills the need and pay the salary. The mission provides the home and a vehicle needed for village visitations. For several years, this was a bicycle, but through helpful people I knew, I was able to send funds for a motor bike. The government appreciates what the mission hospitals are trying to accomplish in the way of free maternity care, all immunization, and leper and T.B. care, which relieves the government of a heavy load. Missions provide 35% of all hospital beds in East Africa and operate on 300% occupancy!

The contrasts between our Western hospitals, even those in outer areas, and the ones in East Africa are so broad, it's hard

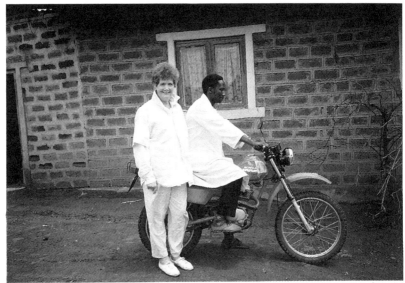
Doctor on the motor bike, which makes village visitation much easier.

to compare them. They are very basic, cement-floored, tin-roofed constructions, with basic iron cots, foam pad mattresses and faded sheets and blankets – no bedspreads here. We would probably call them unhygienic. They never, ever have enough instruments, many times having to fashion them out of whatever is available. I read of a doctor in Zaire who created an emergency instrument out of a bucket handle when forced to carry out a craniotomy. Those early Missionary doctors certainly improvised to a high degree and even now antibiotics are always scarce, as are most medicines. But even so, this center is a God-send to all the villagers in a great area surrounding it. When we lived there, most babies were delivered in the hospital – a fact which brought the death rate of mothers and babies down drastically – and now they are training village women to be mid-wives. Those interested fill out an application and attend classes at the hospital. AMRIT, a UN organization, provides the instruments, lamps, disinfectant, soap and gloves. If the doctor detects a possible problem with a mother or baby, she is admitted to the hospital for the delivery.

I remember hearing of problems with birth control. The traditional natives want children.

"Without sons and daughters, who will take care of me in my old age," they ask.

Condoms and pills work if used, but in some places women use the condoms for small thermoses for water! Husbands found them useful for keeping their tobacco in, and as far as the pills go, at first women were swallowing a month's supply at once as it was such a bother each day. And suspicious villagers wondered if it was an ingenious plan of the *mzungu* to keep the black population down so they could still reign supreme.

In a country rife with diseases of all kinds, Dr. Festo never knows what he is going to face in a day. His outpatient clinic is always busy, as is the dressing clinic. His staff consists of 17 people, some paid by the government and others by the mission. The main problems he finds are diarrhoeal diseases of all kinds, all sorts of parasitic infections – worms have always been a serious problem with villagers in Africa. Hook worms affect the intestinal mucus membrane, causing acute indigestion and increased anaemia. Common round worm is another problem; an infected person can have as many as 100 squirming around in him. Micro-filaria will infest the victim by the thousands. Certain species are microscopic, moving freely throughout the body, causing all sorts of problems. Sometimes swellings resulting from the worms develop into a condition called elephantiasis, causing very swollen and deformed limbs. One could go on and on – there are effective medicines, but shortages always prevail. Throw all this in with tropical ulcers, polio measles, meningitis, cholera and malnutrition, leprosy and malaria and you have but a sample of the diseases these doctors face.

In Tanzania, if people reach the age of 50, they are considered very old and every sixth baby will die before it reaches its fifth birthday. Babies have no resistance to the many diseases because of malnutrition. One malady I did notice were babies with hernias. The Simgalas' housegirl had a toddler

with a huge one and I noticed several others. On asking, I learned that hernias are very common and when left alone, seem to pop back in when the child is two or three.

I didn't see any people troubled with jiggers, but they could certainly have been there. Jiggers are ground fleas which burrow in your feet, usually under the toe nails, laying their eggs there. This turns into a round lump like a small pea, which has to be dug out with a sharp pin. I have seen natives with a safety pin hung in their ear just for such a purpose. I read that jiggers arrived in Africa by ship from South America and have really thrived in the dust. This is dynamite in a country where so many go barefoot.

Dr. Festo also has to deal with eye infections on a regular basis, especially among children. I've dealt with eye infections personally. I often had mothers at my door for medicine for their babies and children with dreadfully infected eyes. It is dusty and windy there, and with little water and living in mud huts, it's little wonder. I used antibiotic eye drops, which worked wonderfully well and when I ran out, I resorted to the old time treatment – washing the eyes with a boracic acid solution, which took longer, but was effective. The sad thing is, if these infections are left untreated, the child can eventually lose all sight.

V.D. is still running rampant in East Africa, but AIDS is completely out of control. Many people go to the coast for work and pick it up, bringing it home to their families. There are areas in Tanzania where 85% of the population tests positive. Being a bit fatalistic, many Africans say, if God wants me to get it, I will, and they go on with the same lifestyle. The prostitutes are 70% to 80% positive over the country. Young girls move to the cities, trying to find jobs, and turn to prostitution, and there are hundreds of AIDS orphans upcountry. Some say that's where AIDS had its beginning. Some propaganda floating about states that Russia or the U.S. made up the virus to kill the Africans and steal their country, and many firmly believe this. Sixteen nurses died of AIDS in Northern Tanzania, contracted while delivering babies without gloves.

The mission hospitals are extremely careful. Many times their patients are first treated by the witch doctor. Often this treatment involves cutting the patient with an old razor blade, spreading infection and now, AIDS. Even at Miss Beimer's new mission, where they always felt secluded, AIDS has crept in. One man married a widow, not realizing her husband had died of AIDS and she had it. They had a baby before she died; it died and he was near the end.

Chest problems are common, as are leprosy and T.B., but the most prevalent and serious disease is malaria. The doctor sees at least one case a day. Malaria is new to Sumbawanga. In the 70s, there were practically no cases as there were few mosquitos. We didn't even use mosquito nets. But now malarial mosquitos have arrived, coming in on fish from Lake Ruckwa. Many years ago, with the roads so poor and little transportation, it took two or three days to bring fish up and any mosquitos on the goods would perish, but now the same trip takes only two or three hours, and many mosquitos arrive with each load. To an expectant mother, malaria is often a death sentence. In fact, 88% to 90% of recorded deaths at Kilangala were caused by malaria. The malarial strain today in Tanzania is particularly virulent, developing quickly into the deadly cerebral malaria. A patient with this loses his mind, and if it doesn't kill him, the people in his village call the mentally-disturbed person a wizard! Chloroquin phosphate, the medicine used for years, is now ineffective and the doctors are hustling to find a better one – even using quinine, which was the main drug used decades ago.

As Doctor Festo toured me through the hospital, I had mixed feelings. So poor and basic, but on the other hand so beneficial. Their needs are monumental – there is just no equipment, the lab is bare and the one basic microscope was locked away. This day, there was only one male patient in the hospital and two female ones – a child suffering severe malaria and a young woman who, I thought I heard, was bitten! Now that was interesting. I couldn't wait to ask Roza what it was that bit her. Roza was also curious and went to check and came back chuckling.

"No, Betty, she was BEATEN!"

As in many overseas hospitals, the meals are not supplied. Instead, when patients are admitted, they bring along relatives, who use the kitchen provided to prepare the food. Down through the years, missionary doctors have had to work around a host of relatives sitting about the room. Actually, only a few minor operations are now performed at Kilangala, with all serious cases going into the government hospital in Sumbawanga.

I noticed a new building under construction near the hospital and learned it is to be a special isolation ward for T.B. and leprosy patients requiring hospitalization. Five beds for each. They cannot admit lepers to the regular hospital, even if they are not contagious, as the other patients would leave in fear. There is still a great stigma surrounding leprosy and people are in real fear of it. Now it can be cured, very quickly if caught early, but taking two or more years, if left too long. It's a long course of treatment, but the doctor believes leprosy can be completely eradicated if all the health units in the country fully participate in a program of case-finding, treatment and education and, more important, follow-up. The follow-up is the main obstacle to success because of the vast area to be covered and the limited transportation. The patients, once started on the medicine, stay with it until they start to feel better. Then figuring they needn't bother with *dowa* (medicine) any longer, they take off, and when the doctor arrives he has to hunt, sometimes for weeks, to find them. The sad thing is, when brought back, they have to start the treatment from the very beginning. The isolation ward looked great.

"Hey, I'd like to make a blanket for each of the ten beds, okay?" I said to Johnson.

His eyes snapping, he asked, "And sheets too, Mama Betty?"

"Sure, but I bet I get my work done before you finish this ward!"

"You're on, Mama, you're on!"

As Dr. Festo escorted Johnson and I through the hospital, I was introduced to the matron, Margaret Mwotsi, a slender, beautiful lady. She had been handling the matron's duties very efficiently for three years, living at the mission. Her husband is a government crop advisor, and his nickname, "*Bwana Shamba*" suits!

An integral part of the Medical center is the well baby clinic. Before giving birth, the mother's weight and health are carefully watched for the nine months and at birth, the baby is checked, weighed and immunized. The mothers are instructed in health care, proper nutrition, proper hygiene, etc., in a firm belief in preventive medicine. As I watched the

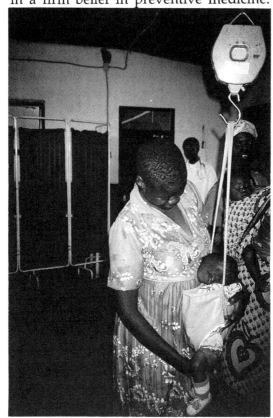

village Mamas sitting on a bench waiting their turn, each holding a bright-eyed baby, laughing and chattering away, it reminded me of our own well baby clinics. Only these Mamas were just a bit more colorful, dressed in their brilliant *kangas* in all the colors of the rainbow. The baby scale was hanging from the ceiling, with a sling to hold the precious cargo. Health posters adorned the walls, instructing

Weighing babies in the well-baby clinic.

all who read them. All in all, it was a cheerful, busy place, one the new mothers were happy to come to for help and instruction.

Even in this clinic, the nurses and doctor have to fight superstition. It's deeply ingrained in a lot of Africans, even now, and the staff still have to fight it now and then, with good humor as well as common sense. For example, some believe if a wizard walks around a pregnant woman three times, she will have a long and difficult labor, and if a young child dies of diarrhoea or vomiting, the mother is branded an adulteress. Of course, Christianity is slowly wiping out a lot of these beliefs, but they are deep set. The Medical Center also has a very active immunization team which visits three villages, three times a month and this has really cut down on communicable diseases. I remember Dr. Sipemba writing to inform me the center had recently received accolades commending them for their work in this area. While there, I spent a morning with the doctor in his office, anxious to see what cases he would encounter in a day. His office, like the rest of the hospital, is basic and austere, but the care given is professional, thorough and gentle. The patient's chair was a typical stool carved out of a tree trunk, solid and, to me, quite attractive. If it hadn't been so heavy, I would have loved to lug one home.

1. A village Mama came in, all wrapped in several *kangas*, in obvious pain with a severe toothache. She was checked over and sent on to the young man in the next office for tooth extraction.

2. A mother with a young toddler, severely burned after spilling boiling water on itself. This brought back memories of the many mothers who brought toddlers to me with severe burns from falling in the cooking fires (*So This Is Africa*). The doctor prescribed burn cream, an antibiotic to prevent infection and a pain killer.

3. A man came in for a prescription refill and had it okayed. Then he was off to the pharmacy.

Doctor and patients.

4. Another toothache victim – I soon realized that even though the people have beautiful, strong white teeth, they are still plagued with cavities.

5. A young mother came in with a three-year-old for a general check-up. Throat, glands, hearing, etc.

6. A child with a cast on its leg. He had suffered a partial rupture of the knee ligament and had been in a cast for six weeks. It was removed.

7. A worker from the orphanage came in with a preemie, wrapped securely in four blankets, no less – this baby was not going to catch cold! It had a rash on its throat – it proved to be heat rash!

Between patients, I glanced about me and noticed a government chart, listing various medicines and their use, tacked up on the wall and beneath it a brilliantly-colored poster warning *Avoid Injections – Fight AIDS!* I knew, however, that the center used disposable syringes and needles when available, and always used disposable gloves. I then walked through to the dentist's office – to use the term loosely. It consisted of an old wooden bench and a counter, on which was placed a bottle

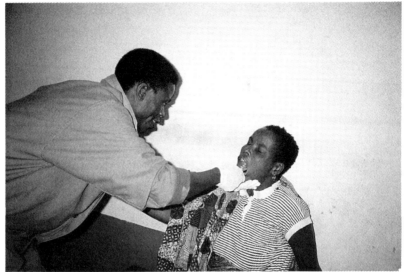

Alfred pulling teeth – he has high hopes of taking a dental course in Sumbawanga.

and a syringe and two antiquated instruments; not a dentist's chair in sight.

Actually, there is no trained dentist at the Center, just Alfred, a tall handsome young man who learned the art of tooth extraction from Dr. Lumbwe, when he was alive. Alfred would love to take a dental course in Sumbawanga, but the funding is not available. But I was pleased to see him using disposable gloves. He had already frozen the area and was in the process of loosening the offending tooth. Now watching a poor victim in the throes of having a tooth extracted is not my favorite occupation, so I started to back away, but Alfred stopped me.

"No, Mama, stay and watch me do my work!"

So I was forced to stay and watch as if he was painting the Sistine chapel or something. What the patient thought when she saw this strange *mzungu* watching her in pain, I don't know. Probably wishing I was in some spot slightly hotter than Hades! It proved to be a tenacious tooth and as Alfred

tugged and swivelled, the poor woman clung to the bench, her legs lifting with each yank. By then I was getting desperate.

"Oh get it out!" I groaned to myself, but just before I was about to grab the forceps out of Alfred's hands and finish it myself, out it popped. The patient sat up with a smile and I got out of there before I passed out.

If you want to find out what it was like in the front trenches for missionary doctors, a good read is Paul White's *Doctor in Tanganyika* series.

With Strong Hands and Willing Hearts

A fervent dream of mine for many years was to visit the children's home at Kilangala. This home was a pet project of mine and my heart was firmly entrenched in its midst. I had helped where I could for many years, but after hearing that Dr. Lumbwe had lost a child to hypothermia, I was horrified. Losing children to one of the many diseases common in Africa is one thing, but to hypothermia? It just was not acceptable. It was also something I could help prevent. No child need die of the cold. So I had crocheted 35 large crib-sized blankets, one for each bed. They weren't fancy, just solid granny squares sewed together, and some of the colors were wild, to say the least, as I used odd bits of yarn my friends gave me, but so what? The children would be warm. So you can imagine how much I wanted to see this handiwork on the beds. This home is a comparatively new one, opened only four or five years ago, and is quite impressive, so clean and in good repair. I was thrilled to see it.

Johnson had informed them of my arrival, so by the time I entered, the children had all gathered and they welcomed me with a song – translated meaning, "We cover our guest with many flowers" – a special song in my honor. I'm an old softie and they so moved my heart, I had to hold back tears. I was escorted into the rooms, finding them bright and clean, each bed made up with a blanket I recognized. What a feeling of satisfaction I felt – one person can make a difference. I im-

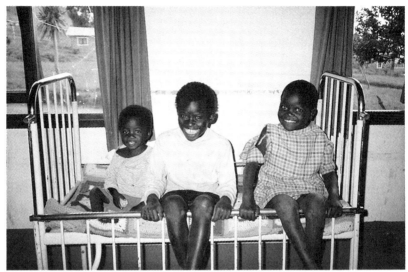
Orphans sitting on blankets made by Mama Betty.

mediately thought, "I'll just go home and make some more!" which is exactly what I did.

There is a desperate need for orphanages in the vast area of the Wafipo plateau. It's agonizingly poor and the mortality rate of mothers is extremely high. So many times, a pregnant woman will contract malaria which, 90% of the time, proves fatal, passing away as she gives premature birth. The new little preemie baby is also handed a death sentence, unless relatives can get it to a children's home. There the child is cared for and on reaching 4 or 5, if possible, it is returned to the father's family, having been given a good start in life. If for some reason this isn't feasible, or if the father won't accept the responsibility, the children's home will continue to care for the child. These little preemies are not born into a world of incubators, but are kept alive with hot water bottles, many blankets and the immense love and care of the nurses, even though they weigh less than two and a half pounds at times.

There are 10 inside workers at the children's home at Kilangala, with two outside workers – one, their cook, and the other a gentleman whose main job is doing the orphans' laundry, an immense job which he does with great pride and

competence. The washboard I had dragged all the way from Canada was for his use, but I was not sure he knew just how to use the contraption! I couldn't help but think how many diapers were needed each day. They use the old fashioned flannelette ones, no disposable ones here, or the new padded velcro ones, which take too long to dry. And just think how many baby clothes, sheets and diaper pins are needed!

Roza told me she never has enough funds to pay for the baby formula – it just takes so much for these preemies. She tries to keep it stockpiled, buying it in Mbeya or Dar when she is on safari, but she still finds it a great worry. The children were all bright and happy, giggling away, gazing at this weird stranger. Good nutrition is of upmost importance and Roza watches over it carefully. The lunch this day was *ugali* (maize flour porridge), sauce made with fresh tomatoes and sardine-like canned fish. Each breakfast, they are fed millet porridge. I left the home with a warm feeling and a certain sense of awe and wonder. All these little children owed their very lives to the Children's home and its caring people. I made note of what I could possibly send which would be helpful, possibly toys, clothes and maybe a few cheerful posters for the walls. It would be the least I could do to help. I wished fervently I could do more.

As we turned a corner on the way to the Bible School, we came upon two men butchering a goat, strung up in a tree, future food for the students. Maybe a city lady would have blanched, but I'm a farmer! The Bible School is a busy place at Kilangala; there were 25 students enroled this term, in the capable hands of Peter Mageza, the principal. Some were there for the special 4-year course, before going on to theological college. The students are not required to pay room and board as such, but each gives a contribution of 1 000 shillings when they enrol. It's quite a small school, but a larger one is being built in Sumbawanga. With Johnson touring me about, I was led like a lamb to the slaughter into a classroom where lessons were in progress, where I was met with many stares and dead silence. When I feel embarrassed or unsure, I usually giggle, bluff or act smart, which I invariably regret afterward. In this

case, I walked to the front of this austere group like I knew what I was doing and told Johnson at the back I was taking over the class for the day. Thankfully, I was met with great hoots of laughter as the teacher introduced me. I hate being paraded, but it worked out better than I could have anticipated.

As we were strolling about, I heard an engine putting away and was told it was the mission mill. Now for every villager, the mill is of utmost importance, for without it all the maize they have grown would be almost useless, and maize flour is their staff of life. This mill runs every day, doing the milling not only for Kilangala, but also for many nearby villagers. A small fee is charged, about one quarter the going rate elsewhere, and this money goes into the mission coffers. One day, like all engines, this one broke down. I asked Moses what the problem was.

"It's leaking Mama."

"Oh," I answered, "A leaking gasket possibly!"

This was a definite bluff of the first order – I wouldn't know a leaking gasket if I saw one, but had heard the term. Moses was duly impressed and I got out of there before my bluff was found out.

In October, 1993, the mission opened a small coffee shop, as many of the workers needed a place to go for a quick cup of *chai* or a soda. They also serve a special bun-like treat called a *kokotindi*, which resembles our hot dog bun. A girl was hired to make doughnuts and these buns, right on the premises, in a pot of oil set over a small charcoal burner. Right beside the coffee shop is a small *duka*, where you can buy a few essentials like kerosene, tea, cooking oil, sugar, and a few pens and scribblers. And no *duka* would ever be without petroleum jelly by the jarful. It's a cheaper type of Vaseline and every bath night each child is liberally rubbed in it from head to foot until their skins glow. I find it wonderful for dry skin, especially the cracked skin on my feet, which I always have trouble with when wearing thongs. There is also a printing press at

Kilangala, which is now rather outdated and overworked, but is certainly better than nothing.

I wish everyone could visit the mission and see how nicely it's laid out, with many trees planted by Johnson at various times over the years. Lovely flower borders surround part of the hospital, mostly made up of cosmos and marigolds, which thrive in the Sumbawanga area. Many of the brick buildings have flowering vines cascading up and over windows, which were in full bloom while I was there. Memories of my flower beds at the ranch flooded back. The former owners of the ranch had left in '63, so when we arrived in '76, I found real rosebushes and other flowers among the debris. I grew nasturtiums, which never did die down, lasting for the two years we were there. In fact, they climbed a seven-foot brick wall and bloomed incessantly. My village friends couldn't figure out why the *mzungu* would grow useless flowers, when she could grow something edible. I didn't even attempt to tell them these flowers were food for my soul!

I met some wonderful characters on this trip, as I seem to on all safaris. Johnson and Roza are a paramount example. They are in complete control of Kilangala and also help Miss Beimers with their sister mission, Katembo. It didn't take long for a picture to form in my mind. Kilangala, which keeps growing and developing amid turmoil and trouble, little money and immense problems, is held together by these two amazing people. With a deep faith in God, they are dedicated to holding it together. They truly are the Mother and Father of the Kilangala family and extended family. There is seldom a moment in a day when someone is not at their door for help with a problem, either mental, physical or spiritual. Both are fluent in Swahili, Dutch and English, as well as several tribal languages.

Johnson is an enigma of sorts – larger than life, standing well over six feet, with the shoulders of a football player, large in body and spirit with a great belly laugh you can hear over the mission. He tends to dwarf all who stand next to him. Extremely gregarious, while commanding respect, he can

make a joke of anything, laughing uproariously, black eyes snapping, but also discuss subjects so deeply you need a mental pick to keep up with him. Johnson has had a bit of a problem with high blood pressure and is now on medication and other restrictions this condition demands. His stress load is great, but he can't seem to find the time for the exercise he's supposed to take.

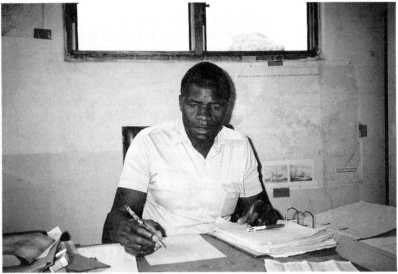
Johnson at his desk.

Roza is the calm to Johnson's exuberance. A tall, pretty lady, she is very quiet-spoken and always in complete control, although she can be a hilarious mimic if the spirit moves her. To me Roza epitomizes the best of her two cultures, Tanzanian and Dutch. Neat, clean, dignified, she seems absolutely tireless. Johnson says it's because she's six years younger than him, but he doesn't seem to tire either. Roza feels equally at home in either culture. She is treasurer for the mission, keeping immaculate books. She also is always trying to help the women in the district. She recently organized a women's group at the mission – not for the first time, she tried it a few years ago, but so many problems arose, it just folded. But this time the group seems more promising. The members meet in the social hall three times a week, and their agenda is the same

as any Ladies Guild group in our own churches: helping the poor, the village women, teaching proper nutrition, cleanliness, needlework and providing guidance in spiritual matters with Bible study and prayer.

Roza had several sewing machines arriving by container, which she had organized on her last trip to Holland. These machines will be used by the mission ladies, but all interested village women, who wish to learn to sew, will be welcome, with the hope of making small garments for their children and for sale. She also has a solar cooker sample on board, and if it works well, they may manufacture them at the mission to sell cheaply to those interested. Roza's deep desire is to bring the village women out of poverty and ignorance. But she also wishes to have a good outreach program, meeting regularly with other church women in the area. But Roza's heart is with the orphans, and her training in Holland in child and youth care helps immensely as she mothers each little child. The happiness and welfare of each one is of the utmost importance to Roza.

Another area Roza controls is the store – not actually a store, it's more like a depot where all in-coming parcels and bags are sorted and stored according to size, area of mission they are for, etc. When we lived at the ranch, one of the joys for me when visiting the mission was helping sort these in-coming parcels. Any old hand-knit sweaters which we felt were too shrunk or shabby, we'd unravel and roll into balls to be used by the village ladies' group, who came once a week for instruction. They would crochet these bits of yarn into granny squares of all colors and hues and sew them together into vests and jackets for themselves.

At that time, the shelves were always full of good used clothing for all – babies, children, adults. But when I looked in this time, to my great dismay, the shelves were bare, with only a few old jigsaw puzzles on one lone shelf and some material I had previously sent for curtains. Seeing the look of horror on my face, Roza explained, "We just don't receive bags of good used clothing any more, possibly because of exorbitant postal

rates." The mission groups they heard from regularly just haven't enough funding to help. But the Mission needs used goods. They clothe each little orphan from the moment it is accepted, and the mission workers and villagers used to be able to come and get what was needed – a man's shirt, a dress or children's clothes –for a very small fee. If they didn't have any money, they could pay with a few eggs, beans or even a chicken. But now the only place to go to buy used clothing is in town at the black market price, which no villager can afford. The ironic thing is, most of the goods sold on street corners in all towns and cities in Tanzania were stolen from shipments Canada and other countries sent as gifts to the needy. There is a desperate need for clothes, especially for children. When I returned home to Canada, a lot of my friends donated clothes, which I packed in sacks the size of a pillow case, at a cost of about 54 dollars for 10 kilograms. One important thing to me is every sack of goods I've sent goes directly to the mission, where I know only the poor will benefit. There are no middle men or office expenses to be paid, and in all the 18 years I've been sending parcels of all kinds, I've only lost one – I'd say that's a record.

Another person I was drawn to immediately was Moses Siame – the little Ambassador! He was the first person I met from the mission when I arrived, hopping right on the bus, claiming my heart. Moses, a vibrant, energetic, handsome young man, impatient with laziness in any form, reminded me of our son, Ian. Same build, same outlook on life and the same quickness of body and spirit. His post is Planning Officer, but he plays a much bigger part in the everyday life of the mission, seemingly able to solve any problem which comes up. A nephew of Johnson's, Moses was living at Tatanda village, but when he finished primary school, he told his mother, "I want very much to go and live with my uncle at Kilangala!" and she said, "Go ahead, son."

This was just a natural progression, actually, as Moses' parents had been working with missionaries since long before he was born. He especially liked the idea of working closely to help the very poor, and spread the gospel without fighting

over points of theology. When he arrived, Johnson, thinking of his future education, thought he should take nurse's training, but that was not for Moses. Instead he went to Bible School in Mbeya, and on completing his course, came to stay at Kilangala. From what I could gather, he seemed to be in the middle of everything which was going on. I never knew where I would see him – under a vehicle, fixing the mill engine, driving or preaching. I'm not sure what it was that drew us together, but I saw him at least once a day and many times he'd just pop in to my little house for a quick visit and many a chuckle. He was the main driver, and whenever I was travelling with him, he'd see to my comfort, bringing extra cushions to sit on and checking to see how I was faring. I do hope this wasn't due to my extreme age!!

It was Moses who designed and built a wonderful swing set for the orphans, made of iron bars to prevent it from

tipping, with a rubber tire as a comfortable seat. Now he's planning a whole play park for all the children. Another of his loves is photography. He keeps me supplied with pictures and slides to show in Canada. He was not impressed with my idiot-proof camera – he wants a professional type you adjust yourself. Moses is married to a tall, shy, very attractive lady, Illuminata, and they have four children. Illuminata's grandfather

Moses & Illuminata.

was an *mzungu* priest, who left the priesthood and married an African lady. The mission hires her father to seed the crop for the children's homes. Moses is my chief correspondent, taking some of the load off Johnson and Roza.

Another wonderful character, who plays an integral part in the daily life of the mission, is an elderly fellow – I use the term elderly rather hesitantly, as I'm getting less sure each year where elderly begins – called Likson. He has been part of the mission for many, many years and is one of the evangelists preaching on Sundays. At sixteen, Likson lost his sight due to complications from measles, and was enrolled in the "School of Happiness," a school for the blind in Tabora, where he learned to read Braille so well, with his nimble fingers and quick brain, that he could read quicker than many sighted people. When I first met him I felt as though he was not only looking at my face, but also deep into my soul – a scary thought! Every morning at 10 a.m., Likson can be found at the hospital accompanying himself on the accordion and singing for the multitudes of patients waiting there to see the doctor.

Likson, who plays each day for the waiting patients.

One day just after breakfast, Roza said, "Betty, come and see your cow!" Now this I had been waiting for. This cow and I went back three years! Let me explain. For several years, I had known the mission needed milk for the orphans, but I couldn't seem to come up with a feasible plan. Thinking powdered whole milk was the answer, I phoned dairies and milk factories both in Canada and New Zealand, hoping to interest someone in providing milk for these kids. It would have to be donated on an ongoing basis, as I couldn't afford to buy it, the price was exorbitantly high. But nary a soul could I interest. For a few months I gave up, feeling this problem was insurmountable, but one night it hit me – a cow – a blessed cow – they needed a cow! The next day I mailed a letter to Kilangala, post-haste!

"Can you purchase a milk cow in Tanzania and how much would it cost?"

I didn't stop to think where I would get funding; I just knew this was the way to go. In two months time (it takes a month for a letter to go from Canada to Sumbawanga), I received a reply.

"Yes, they could purchase a cow for $600.00 Canadian."

They also said not to rush it, as they had to build a milking shed first! Not rush it – I still hadn't figured out how on earth I'd raise the money! I'm sure there's not a thing I hate more than canvassing for money – no matter what the cause – I'd scrub cement floors all day, but don't ask me to ask for money! But I also knew how badly that cow was needed. I mulled it over for a few days, asking myself the odd time how I ever get myself into predicaments like this. But one morning, as I was stirring the porridge, the idea just came from nowhere. There is a large Mennonite community near our farm and many of them are dairy farmers. Besides, any Mennonites I know are God-fearing, caring, compassionate human beings. Would I dare approach them? You bet I would! I phoned a friend of mine in Linden and explained the situation.

"Alice, can you tell me the name of a dairyman who might just like to help?"

"Sure Betty – try Mr. Toews, he is a dairyman and a fine person!"

On contacting Mr. Toews, I explained my mission.

"Is there a chance you and some of the other dairymen in the district could supply a milk cow for a mission in Africa?"

During the long moment of silence, I realized he might have thought I wanted to parcel up one of his prize dairy cows and mail it off!

"What I mean, Mr. Toews, is would the dairymen in your area be interested in providing the funding to buy a cow over there?" I queried, "It would cost $600 Canadian."

"Well, yes, that could be possible, let me get back to you!"

So I left it in his capable hands, did a chicken leap in the kitchen and went on about my work. In about a month, Mr. Toews was at my door with a cheque for the cow. Sometimes when I'm overwhelmed I cry, and sometimes I giggle – this time I did both, with the odd hoot in-between. It wasn't long after I heard from the mission. A milk cow was standing in its own corral at Kilangala. Not just a plain old cow-cow – this was a very special cow, a purebred Brown Friesian they named *Riziki*, which in Swahili means sustenance or food of life! Since then, Riziki had delivered a lovely little heifer calf. As I gazed at the two of them, I couldn't help but tear up. I wished those Mennonite friends of mine were standing there with me. She truly was a lovely cow. The milking shed they had constructed for the cow was really quite superb. It had a cement floor with a good gutter and feed bunk; it's a typically African design, but certainly all that's needed.

When Roza and I arrived, Riziki was standing in the shed, waiting patiently to be milked. The calf, held by a rope around a hind leg, was led in and allowed a couple of sucks so the cow would let its milk down. After the udder was well washed,

the boys set to work milking her. In case you wonder why it takes two boys to milk her, let me explain; lacking a real milk pail, one fellow crouched holding a saucepan on the one side, while the other milked the cow from the other! It was a small saucepan, so a great deal of time was spent running over to pour the milk into a plastic jug, then dashing back again. The cow gave at least 8 litres a day of very rich milk, with hopes of more when the rains bring on the pasture. Presently she is fed grass, which the men cut with *pangas* and haul to the reigning cow queen in sacks. She is also tethered out each day, so she can scrounge what grass there is until the rains arrive. The whole cow operation is under the control Chrisati Sichone, who takes great pride in his work. A bright, vibrant youth, he told me "Mama Betty, no ill will ever cross this wonderful creature's path while I am in charge!" like he was guarding the Queen Mother at least.

A few days later, I wandered over to the milking parlor with Roza. She wanted a picture of Mama Betty milking.

"Oh brother," I thought.

Betty trying her hand at milking Riziki.

I know which side to milk from, but that is all. I had tried milking only once in my life and as I was valiantly pulling on the teats, Bill said with a certain amount of disgust, "Bets, you might just as well go to the house!" But I'm a master bluffer, having practised the art for years, and was out to prove something. I crouched down (there was no stool) and propped my head against its flanks. I grabbed the teats and, remembering some long-ago instruction, I squeezed and pulled at the same time and, lo and behold, out squirted some milk! My first thought was, "Oh heavens, I've ruptured her!" The two boys gave a sort of a strangulated AHHH! so I just kept on, squeezing and pulling. I even developed a rhythm.

"Ha, I missed my calling! I could be the next milk maid of the year!"

But the boys were so surprised, they completely forgot to hold the saucepan in place, so I lost all proof of my success. The calf, by the way, was named "Betty" in my honor, a rather dubious one, but I'm sure it's destined to be a show animal!

Nostalgia

Fortune was shining on me the first Sunday I was there, as Roza had planned a safari for her women's group and I was invited to accompany them. Our destination was Nkana, where they had started a new church; the ladies were going to assist their sisters and bring hope, love and support. I hopped in the back of the Land Cruiser, along with the pastor, an elder and an evangelist, and an assortment of women and babies, with Moses at the wheel. As we drove along, I gazed out at countryside, which had changed little since time began. Beautiful white lilies, towering six feet high, were in full bloom, and there were baobab trees, which have always intrigued me. The saying goes that wherever you are and whatever the temperature, you will not starve or die of thirst if there is a baobab tree at hand. Its bark is thick and spongy, the fibres full of moisture, and you can cut a wedge and suck it like a sponge. The trunk can hold 300 gallons of water, which is why elephants have destroyed so many baobabs. Climb a baobab and somewhere deep down in its enormous branches you will find a pool of water. Look amongst the branches and you will find a bee's nest oozing with honey – look further and you can grab a sausage-shaped pod, break it open and eat the cream inside. This amazing tree provides food, water and shelter, but alas, a lot of natives fear it shelters spirits and shy away from it.

Africa is unique in so many ways. There is such misery, poverty, disease and unhappiness, but there is also such breathtaking beauty – an enigma for sure. But we from the

Western world must realize that poverty in Africa has a different meaning from that understood by tourists and visitors. We should not assume that because Africans do not have what the developed world has learned to need, they are poor. They have different needs and a different way of life. Of course there is poverty, but not all we think there is.

The ladies were singing like only Africans can, loud and joyous and in such harmony, it would melt violin strings, and as we passed through the villages, we'd open all the windows and they'd belt it out louder. Driving helter-skelter over an apology of a road, dodging potholes and turning corners, I hadn't a clue where we were. Then all of a sudden, Moses turned completely off the trail we were following and cut across the *pori*. How he knew where to turn, I'll never know, but we bumped our way around bushes and rocks and around some more, finally coming to a stop in the centre of a desolate-looking village in the centre of God-knows-where. Everyone piled out and in seconds I felt like a monkey in a zoo, a feeling I have had many times in East Africa. In a flash, every child in the village was surrounding me it seemed, laughing and dancing about. Roza whispered to me they very seldom, if ever, see a white woman.

We all walked over to the schoolhouse, where the service was to be held, a very basic, strong-looking building with no glass in the windows and bare plank benches. Being so young a church, they were a bit disorganized, and our pastor baptized five babies he knew nothing about! Kilangala has one main pastor, a small, youthful, dedicated man, Innocent Muhanuka, and an evangelist, Bernard Semsoza, who teaches school in a nearby village. A tall, very handsome man, rather aloof, I was sure he was a Masai, but I was told he wasn't. All our ladies were impressive, as the visiting choir, singing with great fervor, dancing in time to the music. Several had babies on their backs, sitting in a *kanga* sling, some sleeping and others yelling. Then the church's choir leader took over and led his choir, which so far consisted of only his own little family – two children, his wife and a baby. They showed great promise, I thought – not to mention courage in getting up in

front of such a crowd. Every person in the village must have been there – curiosity played a part in the attendance, I'm sure.

Just before the main service, I was invited to the front, introduced and asked to say a few words, with Moses translating. I hadn't expected this turn of events and I only hoped Moses would tidy up the speech before sending it on! The service was long – something like 2½ hours, but on 30-minute seats! By the time we were walking back to the open area, I had to hold back from rubbing life into my posterior. As we all stood about, our ladies took over and presented a few Bible stories, with one difference – they acted them out. To just read the Scriptures to new converts could be boring, but let me tell you, there was nothing boring about the acting! Even some of the spectators got into the action, shouting and cheering. The birth of Jesus, Daniel in the lions' den and the Ten Commandments were the favorites.

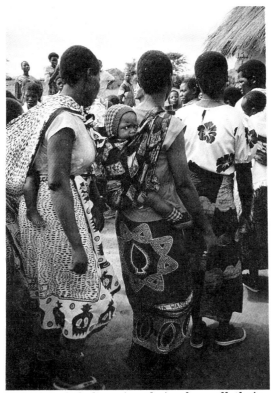

I noticed that our ladies seemed to shine out amidst the sadness and poverty of the village people. They wore clean, pressed clothes, their babies clean and shiny, with such a happy air about them. The village was near Kalambo Ranch, which was one of the four government ranches to

The church ladies give their plays all their energy and talent.

which Bill served as an advisor, from 1976 to 1978. I never visited Kalambo Ranch while we lived there, but Bill had mentioned it was very poor and mismanaged to a high degree. Roza, the Pastor, the evangelist and the elders were invited to eat with the church elder. Roza, not knowing me well or my tastes, had packed a white person's lunch for me, which I could eat in the Land Cruiser. I was rather horrified, as I felt this would be the height of rudeness on my part. Besides, I had eaten *ugali* and boiled chicken in villages before, so we all sat in a little storeroom where we were served *ugali* and chicken, which we ate with our fingers. The setting and the food may have been inferior to some delicate souls, but the love, respect and dignity it was served with beat many a meal at a posh restaurant – besides, as my kids will tell you, chicken is my favorite food. On mentioning how much I enjoyed the meal, Johnson laughed uproariously.

"That whole village would have been very, very surprised!"

The ladies sang all the way home, but now that the visit was over, we all relaxed a bit. Roza, the consummate actress, told wonderful stories, which were met with much appreciation. We arrived home stiff and sore, just at dusk, well content and ready for a rest.

My first visit into Sumbawanga town was bittersweet. Yes, the old jacaranda tree by the market was still there, as was the market, only much bigger. What blew me away was the fact you can buy just about anything you could ever want. It brought back memories of trudging to every little *duka* in town, trying to buy basic supplies. Of course, at that time the border between Kenya and Tanzania was closed. Sumbawanga is not on the rail line and all supplies have to come in by lorry. The roads back then were quite dreadful, sometimes impassable, so we learned to live with many short-ages. But now, with that wonderful new road and better lorries, you can buy anything you wish – even French per-fume.

We stopped at the same bank I used 20 years ago. Back then, it gave me weeks of mental anguish to even get an account

opened. You see, the men in charge felt that women should let their men handle all financial affairs, with nary a thing in their names, but I needed that account. Bill was away most of the time and I needed access to money. Finally, in desperation, I turned to Helge Lein, a Norwegian water engineer, and Carl Madsen, a Moravian missionary, for help and they got their heads together and drew up a paper, signed it and then proceeded to stamp it with every stamp they possessed, no matter what it concerned. My, it was an impressive-looking document, and when presented to the bank manager, I immediately got my account! This time I wanted to cash some traveller's checks and was ready for a hassle, but to my joy, I was met with kindness and professionalism, and although there were many papers to sign, all the staff were very helpful. Johnson and Roza do a lot of business there and can cash just about any type of check and money order from anywhere without any trouble.

I desperately wanted to see Joyce Mbani, a dear old friend of mine, who was the ranch manager's wife when we lived there. We saw each other every day, travelled together, shared our cultures and our love. When Mr. Mbani took a second wife, Joyce left him, one of the first Tanzanian wives to make such a stand in that regard. She now lives in Kongwa and I was hoping we could meet. Johnson decided the best way was to send Joyce a wire, asking her to catch a bus to Sumbawanga. We could spend a few days together out at the mission, as I had such a little time in the country, I couldn't get to Kongwa.

It was high noon by the time we got all this accomplished, so we went to a café near the bank for lunch. Owned by an East Indian gentleman and his wife, it was a little oasis, clean and comfortable. Over *somosis* and *chai* we visited with the gentleman. He had lived in Sumbawanga as a child, but had left in the '60s, returning in the '80s to start up a restaurant. The Tanzanian Ismaili family is a close knit one, so I asked if he knew Sultan and Yasmin in Dar or Ferial in Mbeya.

"Yes, but of course, my wife is a very good friend of Ferial's," he said with a gentle smile, "But Mama, we have also heard of you!"

It always totally amazes me when this sort of statement is made. It seems ludicrous to believe people you have never met, in the heart of East Africa, have heard of you! But that is the way the Ismaili community works, so I just accepted that fact without question.

After lunch, Roza said, "Let's go shopping, Betty." Being a shopaholic, a shop 'til you drop creature, those words were manna to my soul! I love prowling through the dusty little *dukas*, fruits and spices intermingled with the smell of drains; gold, white and black-eyed beans; meat, some still alive; brilliant *kangas* blowing in the breeze; the raucous shouts of the vendors; people rushing here and there; silk and satin in tune with beggars in rags; hundreds of different voices and cadences; and where else could you buy one cigarette, one sewing needle or even one aspirin? I did notice the lack of African carvings and crafts, but was told very few tourists ever come to Sumbawanga – these markets were for their own people who wanted imported goods. They could weave their own baskets – what they wanted was the plastic gimmicks sold in flea markets world wide. To buy carvings, one has to go to Arusha or Dar, where the tourists are.

There were plenty of *kangas* though, which I have always loved. Actually, the *kanga* is a wonderfully versatile garment which can be worn in a variety of ways. Tied at the waist or above the bust, with a garment under it or not, it can also be used as a classic turban or as a sling for the baby. Older ones are used as pads on the head to set the heavy baskets on. All village women wear *kangas* and others wear them in conjunction with western dress. Roza is an expert sewer and she makes up a dress and *kanga* ensemble which I bet even Princess Diana would wear!

One place I was determined to visit was Mlenji Hill, the ranch headquarters where we lived for two years as CUSO volunteers, so one day Johnson announced we were driving

out to see it. I had heard, on my last trip to Tanzania, that instead of raising beef cattle, it was now a government dairy operation. The old road through Isesa village was no longer passable, so we took a back route through Ulinge village. Johnson told me the village government is slightly different now. Each one has its own chairman, a village executive officer and a committee made up of 25 members. This committee deals with all village matters. Above this is a ward officer who deals with several villages, who come to him with special problems. This has been especially helpful for the doctor, as the ward officer will often discover T.B. and leprosy patients and report them. This road was also worse than a cattle trail, I thought, but possibly I was too long away and had forgotten.

On the way, we met two men riding bikes to beat the band down the road, each carrying a good-sized cream can tied on the back. Soon we were at the bottom of the very high hill one has to climb to reach the ranch headquarters and our old house. I had forgotten how narrow, high and winding that hill was! All I knew was, it used to take me a good fifteen minutes to walk up it, puffing all the way. I know people tend to remember only the good parts of such an adventure if they are optimists. I guess if you're a pessimist, you remember the bad, but I had even polished up the good parts of our stay on the ranch, so I was totally horrified when we stopped at the top. It was a total disaster. It made Mr. Mbani's management of the ranch seem stellar. The yard was unkempt, old grass 3 feet high, desolate and abandoned-looking. I wanted to crawl back in the Land Cruiser and speed back to the mission station.

Finally, walking across the courtyard, which 20 years ago would have been crowded with men, I opened the office door and peeked in, and out of the utter darkness stepped a man I took to be a watchman. I don't know which of us was the most surprised – I believe he was hiding in there. When Johnson questioned him, we found out he was the manager! I told him we had lived there years ago and just wanted to see the ranch again, but the man proved to be quite unfriendly, almost furtive, and wouldn't look me in the eye. But who could blame him? A strange *mzungu* bothering him about old times, of

which he knew nothing! But Johnson felt the man was ashamed. He seemed reluctant to show us the dairy operation, so we didn't push. I had seen the dairy herd when we drove up and they looked fat, sleek and healthy, lovely Holstein Friesian cows. He did tell us they ran 215 cows, with 49 milking. The milk was taken to town – ON BICYCLES! Those were the men we met! But two milk cans full from 49 cows? Something was strange, but I didn't find out what. I mentioned to the manager how healthy the herd looked.

"I believe Holsteins are some of the best milkers of all dairy breeds."

He looked startled, "Oh, no, Mama, these are New Zealand cows!"

It was too difficult to explain that even though they had been purchased in New Zealand, they were still Holsteins. On asking if they hoped to expand and milk more, he said with rather a defeatist attitude, "No, then we would have too much milk!"

We wandered over to Bill's and my old house, standing dejectedly on the edge of the hill. It was a sad sight. The big brick pillars on the patio had all tumbled down – the same pillars had had cracks, which opened a little more each time there was an earthquake, about once a month. I guess they did pretty well to last that long. My brick flower box was gone and the terraced garden was all overgrown. I did see one lone morning glory, but the roses and lilies were all gone. My big front room is now used to store sacks of maize and the buffalo horns Bill had over the fireplace had disappeared. But the fireplace, which I used every day, was still intact. What times we had in front of that fireplace! It brought to mind the time I had set a tin of canned herring in tomato sauce in the fire to heat, as my stove had only two burners and they were in use. I forgot to punch a hole in the tin and when it exploded, it was heard down at the *bomas*! I had bits of fish and red coals all through the house, which we ran around trying to put out.

I remembered those special evenings when we had company from town and the mission stations – discussing great and wonderful things into the night! I remember the thrill when we found an avocado tree – with fruit on it! And the old swimming pool under all the debris. As I walked through the house and out the back door to the steps leading to our bedrooms, I thought of Beth and I sitting there alone, watching the ever-brilliant African stars. And would I ever forget the children peeking in my windows, the smell of the Evening-scented Stocks, the warm sun on my face? I gazed out over the immense valley below – what a view! It was that view which I had found so spectacular while living there. The houses and *shambas* and off in the distance, I could see the church at Kilangala.

I noticed Joyce's house up the little path, but thought I'd rather leave it as it was in my old memories of our times together. As we drove away, I didn't want to remember it as I saw it that day, but rather as it was those years ago with Joyce, Mbani and the children, Mr. Ede and Dr. Kessy and Kingazi! But possibly I saw it today as the first day I arrived and the gentle memories I had saved left out the harsher realities, tempered with love and kindness and new friends.

Old Friends, Old Enemies

Another day, Johnson and Roza had a real surprise in store for me. Johnson had been in town, where he happened to meet Carlos Moyer, and mentioned to him that they were expecting me. Carlos and Joanne were old friends we had met while living there. They were in charge of the Livingstone Memorial Mission, where Miss Beimers had worked when first in Africa. In fact, the Demings were Joanne's parents. Carlos and Joanne often stopped at our place when on safari to Dar or other points. Delightful people, dedicated, down-to-earth and completely charming, they had taken over the mission in 1962 and have been there ever since. Africa was Joanne's home – she was born in Zaire where her parents were missionaries. Carlos and Joanne had three children, all born in Tanzania. So I was thrilled when Roza told me of the safari to visit Tatanda and see my old friends.

I had to be up at Johnson's early, as it was a three hour safari over very poor roads. I woke up sleepily, but since I had to wash my hair in cold water (I had no way to heat it in my little house), I woke up in a hurry. This was really a two-part safari, as two of Johnson's nieces were starting secondary school near Tatanda the next day. With Moses ably handling the driving, we set out on what is called the Zambian road, full of passengers chatting away. Likson, the blind evangelist, was telling tales with gusto, punctuated with many great belly laughs.

The scenery was quite marvellous – each corner providing a new and different landscape. Parts looked very poor, and with no rains, even worse than usual. We saw many oxen yoked together, working in the fields, as well as fat, sassy donkeys, which are very popular. They are really quite a wonderful animal – they can walk miles with heavy loads, need very little food and water, and are very sure-footed. Donkeys are used to haul fish up the very steep hills from Lake Rukwa. A lot of millet is grown in this area and is planted in a rather enterprising way. The ground is first ploughed, then the very small seed is broadcast by hand over the plot. Then all the cattle are brought in and walked about, tramping the seeds into the soil. I gathered the depth need not conform.

Years ago, millet was used as a food, but now it's mostly all used for making *pombi*, a home brew which is cheaper than beer. One litre of *pombi* costs 50 Tanzanian shillings, and one litre of beer costs 700 Tanzanian shillings. So there is great incentive to make *pombi*. The village women find it a means of earning extra shillings. In areas where millet isn't grown, it is made of bananas, coconut or even maize. But it is forbidden by law to brew *pombi* if there is a cholera outbreak.

With school starting the next day, the road was full of children in all colors of uniforms, walking to the schools along the road. This was heartening to see. There are primary schools in nearly every village; in fact, today there really isn't a child who hasn't access to one. The Tanzanian government is really striving to keep children in school. At the time of independence, *Ujima* time, all schools were taken from the mission stations and placed in villages. There was virtually no way to enrol your child in a secondary school without paying bribe money to the teacher, no matter if your child was gifted or not. But things are changing for the better. The government has clamped down on this type of bribery and now they are bringing teachers from other areas in to administer and grade exams.

There is also good incentive for both boys and girls to stay single and receive an education. It used to be that girls were

married off at 12 or 14, so the father could collect the bride price of cows and goats, but now the age has risen dramatically, with many waiting until their education is complete. Now if a child is bright, he or she can easily go on to secondary school. As we travelled along, everyone was laughing and singing, with the cassettes belting out the music. But all of a sudden, I was jerked from my reverie when Moses braked in a hurry. I took it to be a bathroom stop, but only Roza stepped out and ran across the road and up a little hill, her arms flung to the heavens.

"What on earth?" I thought, but when travelling I'm prepared for anything, so I said nothing. But Moses saw my bewildered look.

"Mama, that spot is where Roza was born." The village was now long gone, but that spot holds her heart.

The next stop was by the secondary school the nieces were enrolled in. A sprawling complex of homemade brick buildings surrounded by flowering shrubs, it was bustling with young people, blankets and pillows tucked under their arms, heading for the dormitories. After we dropped the girls off, we soon pulled off the main road onto a trail past a village. I noticed this village appeared very clean and well kept, more so than many others I had seen. It had a look of pride about it. Most of the huts actually had chimneys, which was certainly an improvement.

As we pulled in to the Livingstone Memorial Mission station, I was struck by its beauty. Two immense stone houses, which would not be out of place in England, blended into the landscape as if they grew from it. The lawns were immaculately groomed; of course, keeping the grass cut is not only for the aesthetic value, but is necessary to keep the snakes at bay. Carlos and Joanne were on the step waiting to greet us, looking very much as I remembered them, and it was especially nice to see them in their own surroundings.

We had barely stepped out of the Land Cruiser when a distraught father came rushing up, pushing his ten-year-old

daughter on a bike. She had been bitten on the hand by a snake while hoeing in the family *shamba* and was extremely frightened, which was certainly understandable. The dad had tied a tourniquet extremely tight, just above the wrist, a fact which concerned Joanne. As she loosened it she explained, in fluent Swahili, the proper method. Some snakes are so venomous, if the circulation is cut off even for a short period of time, the part below will rot. After washing the hand and examining the bite, they decided it was a non-poisonous snake, as the teeth marks were in a semi-circle, whereas a poisonous one would leave only two fang marks. Joanne said they usually give an injection to give the patient peace of mind.

Poisonous Non-poisonous

I had really given little thought to snakes this trip, but on my second day at Kilangala, Johnson mentioned they had recently killed a black Mamba behind their house in the garden spot. Another time Roza, working about in her house, noticed a movement on the window sill and realized there was a green Mamba decorating the green sill! If it hadn't moved, she would never have noticed it. While I was at Kilangala, two workers, who were digging out a huge ant hill beside the Simgalas' house in order to plant grass, dug out a big snake. Snakes seem to be just a natural part of life for the people in rural areas. It brought to mind my one snake experience while living there. I was up at the Bulongole ranch and went out to the outside toilet, which was just a hole in the ground with a tin shelter around it. As I lifted my foot to step over the ledge, I glanced down and, to my horror, right below my foot was a long black snake curled up. I froze on the spot and watched as it slithered away, where I didn't much care. I mentioned it to the manager next morning and he said, with some delight I thought, "Mama, that was a very bad snake. If it had bitten you, you would be gone in ten minutes!"

One horror story I heard from Joanne: a pregnant lady who was awaiting the birth of her baby was staying at the maternity ward and went out to collect firewood on the mountain behind the mission. The night before, she had a disturbing dream about a big snake jumping at her and biting her. The strange thing was, this was exactly what happened! It was a huge snake and gave a full dose of poison. She was stabilized and taken immediately to Mbala hospital. She suffered terrible pain for many weeks, her leg swelling to twice its size. The doctors discussed amputation, but she wouldn't permit it. She lost the baby the next day and it was thought the fetus had absorbed a great deal of the poison, which possibly saved the mother's life. She limped badly for a year, but even that eventually cleared up.

Even now, if travelling in East Africa, you will often see a man or woman with a finger or toe missing – usually due to a snake bite. It is said snakes do not make unprovoked attacks and one should stand and let them pass. If it's rearing like a cobra or a black mamba, never try to run, because they will beat you to it. Poisonous snakes don't always inject poison when they bite – it all depends on whether they think you are an enemy to be killed or just scared off. If they only want to frighten you, the bite will hurt, but won't kill you. If you are bitten, try to identify the snake, then you'll know how to treat the wound. If it strikes, then recoils, it's a puff adder. If it hangs on and chews, it's a back fanged snake. If it coils up before it strikes, it's either a cobra or a black mamba.

Johnson and Roza, as well as Moses, were from Tatanda, so this safari was a visit home for them. Moses and one of Moyer's sons were boyhood chums and Moses spent a great deal of time there. Livingstone Memorial is an older established mission and is different in some ways from Kilangala, but it is filling a tremendous need in the area.

Our first meeting with the Moyers proves that the world is a small place. When we lived on the ranch, Bill was in town one day and noticed a *mzungu* riding a huge old motorbike with a side-car. Now, we had seen *mzungus* often enough and

also motor-bikes, but not one of this vintage with a side-car, so over he went to check it out. Bill greeted the fellow.

"I can tell by your accent you are an American!"

"Yes," said the fellow, "and I can tell you are Canadian by your accent!"

He went on to tell Bill he had taken some schooling in Canada and Bill, all excited, asked where.

"Oh, just a small place in western Canada, no one's ever heard of it!"

"I know western Canada well," Bill replied, "Where?"

"Oh, just a small place near Calgary."

"Well, I live only 80 miles from Calgary," Bill stated, "What town was it?"

"The town was called Three Hills."

Bill laughed out loud, "You must have gone to P.B.I.!" He was right. The man Bill was speaking to was Carlos. In fact, while enrolled at P.B.I. (the Prairie Bible Institute), Carlos used

Carlos and Joanne Moyer at their mission near the Zambian border.

to pass our gate when out on his Sunday walk and knew many of the local people we did.

The Moyers' home is open, airy and comfortable – having just returned from a furlough in the States, Joanne was still trying to get settled in. As I gazed out their window, a big old turkey gobbler strutted by! But that was just the beginning; a tiny little bush rabbit, which had to be fed milk four or five times a day, was settled in a little box. A young *duiker* (antelope), dogs and cats, even a pet owl, which had a broken wing, and a big old ostrich shared the grounds. Inside the house, a chameleon was curled in a little wooden cage, with a fine wire netting. Joanne, explaining how helpful a creature it was, lifted it out gently and held it near a window where two or three flies buzzed about. A tongue the length of its body shot out, nabbing the fly so quick you could barely see the movement. As I watched this amazing demonstration, Joanne mentioned that one time the poor little fellow dislocated his jaw, but she managed to set it and he was just fine.

After Joanne set the little fellow back, Moses asked me, "Mama, you wouldn't ever pick that creature up, would you?" If I was in my right mind and home in Canada, no power on earth could make me even touch the little thing, but I wasn't home in Canada and in my exotic surroundings, I thought, "Why not?" It was cute and quite dry and warm-skinned. As it hung on with its tiny claws, they reminded me of a kitten's, hanging on just the way kittens do. As we walked through the station, seeing their hospital, dental clinic, church, etc., Joanne told us about the re-forestation project they had instigated. Starting from seeds, they take the seedlings and plant them wherever the trees have been cut and pass out seedlings to anyone wishing to plant them. Since they have set out 70 000 plants in the past five years, the Tanzanian government have recognized their re-forestation program. Eucalyptus grows very quickly and can be used for lumber, especially for rafters – growing up again after the first cutting – and is so hard you cannot nail it without drilling holes first. This tree tends to impoverish the soil; in fact, they were used in Israel to dry up swamps.

The problems and challenges Livingstone Memorial faces are very like the ones at Kilangala. The dreadful eye infections are now on the decline as more and more people have access to health care and antibiotics. Also, Joanne sees far less chest problems, because many of the new huts now have chimneys, so the residents are not sitting in all the smoke. Measles are still a scourge, but are diminishing as both missions and the government are campaigning together, stressing the need for immunization. Government dispensaries, though rather pathetic in Western eyes, are located in most villages.

Protein deficiencies, called kwashiorkor, are too prevalent. The name was coined in West Africa, meaning "red boy," because the child's hair turns a reddish color as the disease progresses. I remember children I tended who also had these reddish highlights in their hair. Another meaning of kwashiorkor is "neglected one." These children are easy to spot, their hair reddish-grey, painfully thin, with the tell-tale edema swelling of eyelids, feet, hands and tummy. More advanced cases come in with bodies so swollen the skin has cracked and fluid oozes out. It's generally found in children 18-months to 4-years-old, as the mothers, by then, have another baby, so even the milk is gone from the child's diet. The worst part is, by the time the mother finally brings the child to the doctor, it's often too late. This is tragic, as it's not necessary.

The villages near Livingstone have the food needed to correct the condition, but still the Moyers have to fight the traditional ideas. How often they hear excuses like, "Bwana, if I feed my child meat or eggs, he will get proud!" Carlos figures, "Better proud than dead!" If they receive a case of protein deficiency, they immediately start the child on a regime of milk, eggs and peanuts, keeping the child at the mission until nearly well, so the parents can see the difference. They still have to fight the witch doctors. Joanne has had several cases of scalding to deal with. It seems the witch doctor's cure for protein deficiency is putting dawa in a pot of boiling water, then dipping leaves in it and laying them on various parts of the child. One horrendous case was a child brought in by a grandmother, so badly burned the skin was

literally sliding off its body. The poor child, in agonizing pain, passed away within a week – a distinct blessing.

While visiting with Joanne, I learned that Dr. David Livingstone Wilson, the great-grandson of David Livingstone, had recently made a trek, following the way his very famous ancestor took about 100 years before. Dr. Wilson took the boat from Kigoma to Kasanga, but his support group with vehicles and equipment stayed with Carlos and Joanne for a few days to do some needed repair work. Then one of the staff, Kennedy Simtowe, escorted them across the border, and on to Kalambo Falls, where a big program was held, with many government officials from Zambia attending. Then on to Bangwelo, where Dr. Livingstone's heart is buried. The video taken of the whole trip has been shown in the States many times.

Wanting to hear Carlos' and Joanne's version of why they are there, leaving a comfortable life in a Western country, I asked them what their philosophy is.

"We feel we were called to do this work," Carlos stated. "We are not here to change people's culture and we don't try to change it unless their culture is contrary to the Bible. We try to help them improve their lives with better farming methods and education, but we are not here to make second-rate Westerners, we are here to make them first-rate Africans!

There have been many changes in the time we have been here. Almost every village now has clean drinking water, which has cut down on dysentery. There is often a lack of medicine, as it has been sold on the black market, but the overall quality of life has greatly improved since we arrived here 30 years ago. Virtually all can read and write and are conversant in Swahili now, which was uncommon back then. Our church has grown tremendously, with many churches started and led by the Tanzanians themselves. We still have many plans, of course, but we are thankful for what we have been able to achieve."

After a splendid afternoon, we left for Kilangala, as we had a long, rough road home. I couldn't help but think of Joanne

and Carlos, who made this same trek 2 or 3 times a week! But Moses collected two big cushions for me – even with all my natural padding, I got stiff and sore! Johnson had spent the day visiting relatives and friends in Tatanda and so was full of stories.

On our way home, we had another snake adventure. It was getting late and everyone was in a sleepy state when Moses braked in a hurry, only to back up, go ahead, back up and repeat this manoeuvre several times. On looking out the windshield, I saw what seemed to be a chunk of rope across the road – only it was moving. Even with repeated backing to and fro' over the snake, it persistently kept moving.

"It's like running over a hose," Moses explained.

It would keep wriggling toward the edge of the road after each attempt, so finally all the men jumped out to finish it off with a rock, but still the snake would hiss and take a rush at them.

"That is a very angry snake!" Roza said with a laugh.

Finally it succumbed and we were on our way again.

Johnson explained, "We always kill a snake on seeing it, we get so many snake bites and there is a village just a mile from here." I proceeded to tell them the story I had heard of a missionary in Uganda; she had gone into her bathroom and just happened to glance in the toilet bowl, where a huge snake was resting. She called the boys in from the yard and they proceeded to whack at the snake with their *pangas* and sticks with great energy. Sure enough, they killed the snake, but the toilet was in a hundred pieces when they finished!

Then we ran into a heavy rain storm, with lightning flashing continually and thunder rolling so loud we couldn't hear each other, but we arrived home safely. After some *chai* and fresh bread, I headed for my little house, scouting extra carefully for snakes en route! It wasn't long until I was so sound asleep even a python could have crawled over me and I'd not have awaken.

In the Spirit of Things

In the morning, I peeped out my bedroom window as usual and, to my amazement, saw a veritable geyser shooting 12 feet in the air near my house. A water pipe had broken, due to the extra pressure from the torrential rains we had been receiving every day since I arrived. As I slipped and slid down to Johnson's, I noticed four other geysers scattered throughout the mission.

"We have simply got to replace our water lines," Johnson stated, gazing out in wonder.

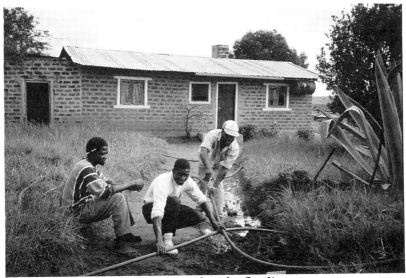

Doing repairs to the water pipes after the flooding.

Actually, the plastic pipes have done well, as they have been in use for many years, supporting a hospital, an orphanage, several outdoor taps and several houses. Their water source is piped down from two streams up in the Kilangala hills behind the mission. The water test proved it to be excellent water with lots of pressure. But as the week progressed, the rains were heavier and one afternoon there was a massive downpour, as though the heavens emptied all they had. The water roared down the hills like Niagara Falls, through the mission compound with a force which could lift an adult off his feet. It swept right through one house, in the back and out the front, sweeping everything in its wake.

"Now, I'd say that's a good way to clean a house!" Moses laughed.

Every day I was there, old memories and thoughts came to mind. One thing I had forgotten completely was how very dark an African night can be if it's clouded over. Each night after supper, I'd walk back to my house, missing it completely a couple of times and having to backtrack. The mission has thought of getting electricity in, something which may be feasible in two or three years. But even Sumbawanga town hasn't got power as yet. The mission had thought of harnessing the three main streams on the Kilangala hills, but they weren't powerful enough. A windmill was another idea bandied about – there is a wealth of winds most times in the area, but there are also many still times when there isn't a breath of wind.

Each evening I wondered if I'd run into some creature on my way to my house, always shining my dim flashlight here and there as I walked along. I really knew better, as even when we lived in the area nearly 20 years before, there were no animals left, just snakes and monkeys. Still, after hearing snake tales practically every day, I'd check under and in my bed before retiring. Roza did tell me, though, that in the forest atop the Kilangala hills there are still animals – small and large antelope, wild pigs and even one very old leopard, who visits the mission now and then in hopes of nabbing a goat. Also, at

certain times of the year, lions, elephants and buffalo have been seen as they migrated from Lake Rukwa to Lake Tanganyika. It was tales like these which put a certain zing in my step as I walked home.

One subject I've always been interested in since I was a little girl is witchcraft. In fact, any book which boasted even a paragraph about witchcraft, I'd devour. I think this interest was strictly for the scare value. So it was just natural, when I lived there, that I'd quiz Joyce about the witchdoctors (*So This Is Africa*) and when any local missionaries, priests or teachers were visiting, they would also be thoroughly questioned. Sumbawanga was a great place to start an investigation, as it was, and still is, the center of witchcraft in Tanzania. The government, at one time, moved all the witchdoctors out, sticking them all in one village, but ironically, that year that village was the only one to receive enough rain! Each tribe, and there's more than 100 different ones in Tanzania, have their own witchdoctors, but the witch doctors of the Wafipo, the prevalent tribe in the Sumbawanga region, are very evil – much more so than all the others. There is a saying, "Thieves even leave you alone, when they find out you are from Sumbawanga." (I thought this might be handy when travelling to Dar!)

Witchdoctors, in general, have a terrible hold on the people. They are petrified of witchdoctors and spirits and their whole lives centre around them. Dr. Lumbwe told me a story of having to physically force a patient, who was suffering with cerebral malaria, out of the clutches of a witchdoctor in order to admit him to hospital. The man's relatives believed that someone had sent an evil spirit to kill him and that the severe convulsions, which are a symptom of the illness, were due to a fight between the evil and good spirit. Most doctors in East Africa are forced to deal with witchdoctors and their treatments. Most Africans believe that all illness or trouble, mental or physical, is caused by spirits, whether evil, angry or good, or by a curse placed on them by a witchdoctor. And the only one able to chase away the spirits or lift the curse is another witchdoctor.

When ill, if the patients actually live through some of the horrific treatments and get to a hospital, they are much worse off than before. The doctors then have to not only treat the original ailment, but also the damage inflicted by the witchdoctor. One of the favorite methods of "letting out the evil spirit" is by cutting fine slits all around the infected area – usually with an old, rusty, dirty razor-blade. You can just imagine the infection this practice starts and which now can be a death sentence, with AIDS so prevalent. Many witchdoctors, especially urban ones, adopt some Western trappings, like a stethoscope, white jacket or a Bible, feeling it gives them an air of respectability and will impress any patients who may have had a smattering of Christian education.

Roza actually had a grandfather who was a witchdoctor. She remembers him coming to their home, visiting with her mother, Miss Beimers.

"He was really rather a good one," Roza stated, "And became a good friend. He would go on great, long safaris even into Zambia!

"But Betty, there are varying degrees of witchdoctors – some very evil, but if you show no fear, they will leave you alone. They have been known to try to put spells on people when they are asleep, but usually they don't wish to tangle with a Christian."

But Roza believes firmly that nothing good or positive comes from a witch doctor – only evil. This certainly seems true when you think of a bizarre cult which has terrorized parts of Tanzania for years. This Lion Man cult of Singida, in Central Tanzania, is almost hard to believe. If someone wishes to remove an enemy from the community, he can hire a Lion Man from the local sorcerer-owner, who will arrange for the execution. The sorcerer will have captured or bought a mentally-deficient child and kept him in confinement until grown. Kept in a narrow space, the captive can never stand erect or stretch out, his nails grow to be claws, and he is tormented all his life. When let loose, clad only in a lion skin, he is hired to

kill or terrorize the local population. A priest in Tanzania described seeing one of these poor, sub-human creatures.

"He was crouching in a pit like an animal, spoke no language, and could only grunt. Even in captivity and without his disguise, he was a horrifying sight and made more terrible by being so crude a distortion of humanity."

If you remember, many of this cult were used very effectively during the Mau uprisings.

This brought to mind a story Dr. Harry had told me years ago. The odd time, he would work with one witchdoctor for the good of his superstitious patients. The witchdoctor would refer patients to Dr. Harry at times, and if one had a psychosomatic illness, Harry would enlist the witchdoctor's assistance. One patient of Dr. Harry's believed he had a snake spirit in his stomach, which was slowly eating him, and that he was destined to die within a short period of time. So Dr. Harry and the witchdoctor concocted a plan. Harry and the witchdoctor and patient all sat about a table, which was near an open window. Harry placed a big spike on the table and told the patient that the snake spirit would fly out of his body into the spike when the witchdoctor called it. Meanwhile, the witchdoctor was holding a magnet under the table. As Dr. Harry gave the patient a magnesium shot, the witchdoctor "called the spirit" and moved the magnet, causing the spike to shoot across the table. Dr. Harry grabbed it and with great flourish threw it out the window. By this time, the injection was giving the patient a good hot flush, so much so he was cured on the spot – powerful medicine indeed!

But a new trend today is a "witch hunter." These are people who claim the ability to sniff out witchdoctors, and who tour the country searching out villages in need of their services. When he arrives, he lines up all the residents, then goes along the line, sniffing each one, picking out whoever he feels is the culprit. What happens to the person, I never found out.

I was able to attend a Communion Service while at Kilangala, and what an uplifting experience! I was up early in

the morning, in a dither over what to wear – a position I've been in many times! I didn't have a lot of choice, so I finally settled on an African print *muu muu* I had made. It was rather old and a bit decrepit, but it was bright! The service was to start at 10 a.m., and when Johnson, Roza and I arrived, the church was only half full – but, oh, the singing! The service started at 10:30, but people were still arriving at 11:30. Likson, Johnson, the elder and the evangelist all filed in past the huge pulpit, which was draped with the Moravian church symbol, a lamb with a banner. As I gazed about, I felt the charm and warmth of the church, the men on one side and women on the other, with lots of children of all ages, who even though they had already sat through Sunday School, were so well-behaved. The table and pulpit were decorated with fresh flowers stuck into bottles, and woven baskets served as collection plates. The ladies' choir, as well as a young people's choir, each sang several numbers. Most hymns were intermingled with the loud trills African women have perfected. I was pleased to see they had a lady elder – a dignified warm woman who belied her 72 years. Atupokile had worked at the children's home for 23 years, and on retirement decided she wouldn't like sitting about, so took over the job of cooking for the Bible students. Again I was introduced and invited to say a few words, which Johnson would translate. This time I knew I would be asked to speak, so had written up a small speech the night before, but just when I was called to the front I realized I had forgotten the fool thing! Now what? So ad libbing away, I chatted about bringing greetings from Canada, my love for Kilangala and other inane utterances. I congratulated the congregation on the wonderful growth of the church and mission, which I meant from my heart, and that I wasn't a missionary as such – which was surely the truth! Then I slipped off the platform before I bombed it, but Johnson called me back. I had made another boo-boo. The procedure was to stand still while the congregation clapped in rhythm.

A new group of Bible students had just arrived the day before, and were asked to stand, give their name and where they were from. But they decided this would be a good platform as budding ministers and proceeded to give small

sermonettes, long sermonettes and a song or two each. By the time that was over, everyone stood up and walked out. "Good" I thought, those benches were hard and my knees were not used to kneeling. But I soon learned this was only a break – sort of a church recess. After visiting outside for 20 minutes, we all went back in for the communion service. I know I lose a lot by not being fluent in Swahili, but apart from the language, the service was identical to our Presbyterian communion service. It was a very moving experience for me. To actually share communion with fellow Christians in East Africa was mind-boggling!

"This is the way it is meant to be – this is what Jesus was talking about! We are all brothers!"

One hymn, "Pass Me Not, Oh Gentle Saviour," was an old favorite of mine and was sung to the tune I knew. But another, "I Heard the Voice of Jesus Say," was sung to the tune of "Auld Lang Syne," which brought an unwanted chuckle up from within me! The service finished at two and on the last hymn, the heavens opened and we were deluged, but not one soul was going to going to grumble after such a long drought.

The whole of the time I was at Kilangala, I ate all my meals with Johnson and Roza, which was wonderful. Roza is a top cook and has taught her help all the tricks of great cuisine, so everything set before me was delicious. She makes her own bread fresh each morning in a unique fashion. The dough is prepared exactly as we do it. It's then popped into a big round pan, which is placed into the sand, with an iron plate over top. Next the upper sides and top are covered in hot charcoal. It usually takes 30 minutes to completely cook, but it's well worth the wait. Roza has tried to interest the village women in baking their own bread, but it's hard to break old traditions. She hopes the younger women will be more receptive to the idea.

The meals were always a mixture of Tanzanian and Dutch; sometimes potatoes and other times *ugali*. I found out there are really two types of *ugali* – *simbe*, which has the outer skin and husk of the maize removed, is white and the other, *ndona*,

is whole meal and very nutritious. But I didn't enjoy these times just for the food. No, it was a special time, with very special people. Breakfast and lunch could be hurried, but the supper meal was a big one and on completion we'd enjoy a Bible reading and discussion, which many times was quite lively – especially if Moses was there.

My days started early, with breakfast at about 8, and then I'd visit some corner of the mission, the children's home, the hospital, wherever – taking pictures and notes and getting to know the staff. Sometimes I'd just wander around absorbing the scenery, completely at peace, being greeted by others. I loved this, but found I had to bluff a bit and then disappear quickly before I was found out. I could manage many of the greetings, but that was about all. But the greetings, I knew, were extremely important. There was great delight when I tried to speak Swahili, which is the 7th official language of the world, Johnson told me, but going to a country where "Hi, how are you" is an extended speech, it was hard to adjust to all the greetings.

But any Africans I have known, barring only a few, are extremely courteous, although many *mzungus* who do not know their culture believe them to be the opposite. Courtesy and good manners, especially in villages and rural areas, are taught to the children and are almost a religion. White people thought it was greed when houseboys held out two hands for a gift, but instead tribal manners insist that however small the gift, gratitude is always expressed by taking it with both hands – exaggerating its worth. Similarly, whites used feel their "boys" showed a lack of respect, because they would sit down when whites entered the room, instead of standing up, but African children are taught that to be physically above a superior is bad manners! (Although I can't imagine why a white would be superior in the first place!) Another thing whites found infuriating – if they were standing on the street talking to a friend, Africans would pass between them, instead of behind, as is our custom – but they believe one should never pass behind, as it shows evil intent. Africans were also branded as shifty-eyed – "they can never look you in the eye"

– but this is also easily explained. They are taught never to look a superior in the eye – this is a sign of disrespect!

An African's sense of distance and time is not the same as ours. They relate differently. If you ask a village headman how far it is to the next town, he will say "far away or a day away," but ask his son and he might say it's nearby and could be walked in half a day. The old man could take a day, while the son half the time. If an important person visits a village, the women will greet him or her with loud trills – the men might stand up clapping gently. On leaving, you might be given a chicken, a pumpkin or some fruit – it must never be refused. When you leave, several villagers will walk along with you, carrying your packages. All this and more I had to learn when we lived there, but I had a great deal of trouble accepting the respect they felt I should have, merely because I was white. It took many months before we could work out a way which was suitable for us all.

One thing I noticed this time was the funny looks I received when I hugged someone or patted an arm; this was only natural for me, but rather startled some of my new friends. The whole 2 1/2 weeks I was there, I was a novelty to the

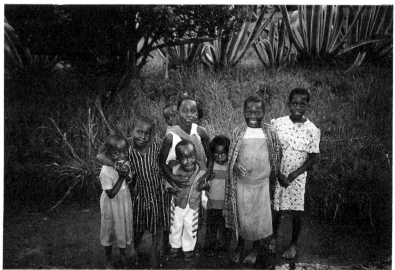

Each day, Betty had little children near her door.

children. As I walked about, I was often greeted with "*Shikamuu*" and a little bow, as adults and superiors are. I kept my pockets full of sweets and often, during the afternoon, a little group of children would gather outside my door. If it was a warm day, I'd sit on my step with them and have them sing – if not they'd sit on my floor. I had bought a funny little musical instrument, called a *zizi*, when I was in Mbeya, but I found to my surprise most hadn't seen one and not a soul knew how to play it except Jinise, Johnson's sister. I remembered seeing such a thing in the movie, *The Gods Must Be Crazy*, and Jinise thought it was well known in Zambia.

Map of Kilangala Mission Station

1. Bible school, which is now used for Mama Betty's School	14. Milling shed
2. Pastor's house	15. Children's home
3. Staff house	16. Kitchen for children's home
4. House of the doctor	17. Garage
5. House of Moses	18. Guest house
6. Printing unit and offices	19. Doctor's house
7. Small house for generator	20. Cow barn (corral)
8. Meeting hall	21. Johnson's house
9. Guest house (used by Betty)	22. Nursery trees unit
10. Staff house	23. Miss Beimer's new home
11. Teacher's residence	24. Hospital and isolation ward
12. Residence of sewing sector manager	25. Church
13. Orphanage workers' residence	26. Hotel for workers

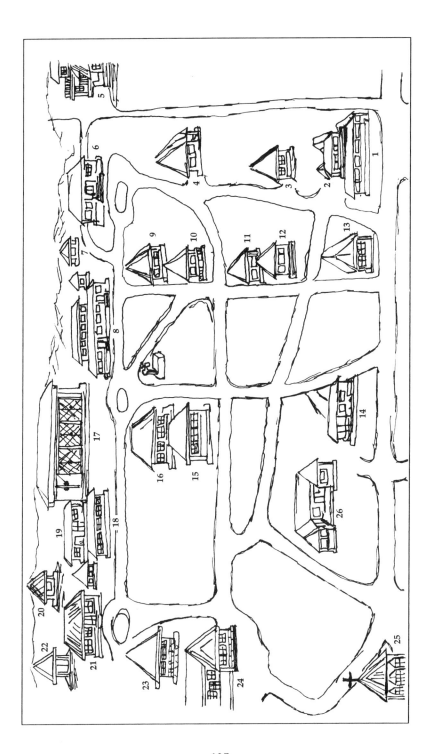

Leavetaking – Kilangala to Dar

Time went by very quickly and soon it was time to think about heading back to Dar. I wasn't worried about the bus trip this time – I knew the new road would make the difference. But the day before I was to leave, I saw Moses sprawled out under the Land Cruiser and I asked him what he was doing.

"Oh, Mama Betty, I'm changing the shock absorbers for our safari to Mbeya!"

Now that was news to me! This way I'd have the opportunity to meet Miss Beimers again. Johnson and Roza decided they needed supplies and medicine soon anyway, so why not give me a lift to Mbeya and get the shopping done at the same time. My last evening at the Mission was a bittersweet one for me. As we visited after supper for the last time, I tried to think of all the things I still wanted to learn about them and this was my last chance.

"Do you ever turn anyone away who comes to you for help?" I asked them, knowing the answer already, but if I was to write this book, I wanted to be certain and I wanted to get a general picture of their own philosophy.

"No, Betty, no one is ever turned away from Kilangala!" Roza stated firmly, "No matter what their tribe or their religion!"

I knew from past experience that the Moravians are known for this. They believe strongly in works and example and helping the destitute. How can you preach the Gospel to people who are ill or poverty-stricken? Kilangala is there to help the poor in body and soul. I remember an old missionary I had met years ago. I asked him, did Christianity really bring a better life to the primitive people among whom he had worked?

"You have no idea of the change!" he replied emphatically. "Those old communities lived in fear! Fear of their enemies, fear of neighbors and family, fear of witchdoctors being bribed by envious people, fear of dissatisfied ancestors, fear of the chief and brutal tribal customs! When they became Christians the fear left!"

Churches and missions today have learned that Western ideas applied to African standards bear rather strange fruit. They have learned to respect other cultures and work with the people as equals. We all know that some of the first missionaries made many mistakes, but I think we should also remember those first pioneers played a very important role – they opened the way. If they hadn't given up everything and come, mistakes and all, there wouldn't be a welcome for today's missionaries who are doing a tremendous job. Remember, it was Martin Luther who stated, "He who does not progress along the way, goes backward." We have progressed. I think we should also realize that 80% of the people in power in Tanzania received at least some of their education in missionary schools! A great many of the missions are now run by the Tanzanians themselves, and they are doing a wonderful job of it and, in many ways, are much better Christians than some of us.

Johnson told me that, at first, people became Christians in order to get jobs. Later, people noticed the mission workers all had clothes and were never hungry, so they said they believed to get the same treatment. But now people are reasoning and really deciding for themselves if Christ is real and if they want to follow in His path. Now it also seems the notorious compe-

tition between churches in the last century is pretty well gone. Wow – now that's the end of my sermon!

The next morning, we were off at 8 a.m. Dr Festo, Johnson and Roza; John (Johnson's nephew) and Abel (the minister's son); and little Anneke (Roza's little girl) were all going. John and Abel were heading for secondary school. It had been an intense time. I had made many new friends, so it was with sadness that I left. We had to stop in Sumbawanga, as Johnson and Roza had business to attend to, then over to Mr. Mehti at his restaurant, to say good-bye and pick up a letter he wanted me to take for his brother in Calgary. Then, while waiting for the Land Cruiser, I wandered into another *duka*, which was owned by a Mr. Premji, as I wanted to find out if he was related to the Premjis I knew in Alberta. He wasn't, but he knew Sultan in Dar – not unusual. But we had a great visit. He and his brother had owned a dairy farm near Mlenji Hill ten years ago. He had a wonderful herd of Holstein cows, but when his brother left he just couldn't keep up.

"I had trouble with the help," he lamented. "They would beat the cows! How can you expect good production when you hurt the cows!"

As he gazed at me, I was sure I noticed a tear in his big brown eyes.

"You know, Mama, you must love the cows and pamper them like a good wife!" he emphasized, his little finger raised like a debutante's at a tea party.

Soon we were on our way. I was perched on two plump cushions, which Moses had brought. By this time, Moses and I were buddies, comrades. I was his mother and he my new son – an amazingly wonderful combination. We drove along, chatting away to the accompaniment of an African singing group on cassette. We made excellent time and before we knew it, we had driven into the sister mission, Katembo. I had met Miss Beimers only once when we lived there, but that was nearly 20 years ago. But you'd never notice any difference – the same small, wiry, little lady, full of energy at 72. She had

her long grey hair pulled back from a face which still showed the classic bone structure of a beauty, wisps escaping as she bustled about, canning mangos in an ancient pressure cooker.

The children's home was full to the brim, tiny preemies in a small nursery room, with two baby cribs surrounded by mosquito netting, and the older toddlers in two other rooms. Everywhere I looked, another little group of bright-eyed children were playing or having a lunch. I couldn't help but think of all the diapers needing to be washed each day – this isn't the world of disposable diapers! And the feedings – not just *ugali*; these babies, like the ones at Kilangala, receive a well-rounded diet. Miss Beimers has to be the eyes and ears for all the children. She is continually checking and correcting the young girls she is training.

Orphans at Katembo – a new orphanage now houses many more.

"Remember, I told you never to put a baby down with wet diapers!" she admonishes one girl.

Some of the beds were metal cribs from Holland, but many were wooden – like a large apple box with legs. The building is an old one and much too small. In fact, when we were there, she had an overflow of five babies in her own very small

house. Miss Beimer's dream is to build a new home, which will hold at least fifty children. Even now, Roza often takes preemies to Kilangala. The children all looked healthy and happy under the mothering wings of Miss Beimers, but she also has another dream – she wants to open orphanages all over the Wafipo plateau so no baby or child need die for need of a home. She will, too, if I know her! Roza and Johnson want her to semi-retire and move back to Kilangala, where a brand new house awaits her. She could then carry on her translation work – she has already translated the New Testament into the WaFipo language. Her health is not good and she has been forced to go home to Holland for medical treatment, but when I asked her when she would retire, she gave a snort of impatience, declaring, "I won't leave here until I find someone efficient enough to replace me here – how could I leave my children?"

Of course, Africa is home to Miss Beimers.

"I wouldn't have such freedom anywhere else, I love it here! I like to go to Holland to visit my family, but this is home!"

Roza, little Anneke and Miss Beimers.

After tea and bread, we were on our last lap of the journey to Mbeya. I looked back to see her standing in the yard waving, a tiny frail figure, and a comparison to Mother Teresa came to mind. As we finally hit the hard top, laughter and singing filled the Land Cruiser. Roza, mimicking who-knows-what; the boys challenging Johnson and Moses, discussing all sorts of subjects. I found if I knew the topic, I could add my thoughts in English, which they could all understand. They would always laugh uproariously at my stories – leaving me to wonder if they were just being polite or if I was really witty.

We arrived in Mbeya about five p.m., pulling in to an Evangelical Church hostel on the outskirts of the city, the Karibuni Center. After we unloaded, Moses and Dr. Festo continued their safari to Iringa for UNICEF medical supplies. Not knowing if they would be back in time, I had to say my good-byes – this was even more difficult than I thought. Moses and I had become very close and I hate good-byes – we both tried little polished speeches, which didn't work, so a great hug had to suffice.

What a lovely hostel – very clean and peaceful with lovely grounds. The flowers were in full bloom – even English roses and dahlias, a lovely spot for weary travelers. Everyone is welcome there if they behave and it cost a mere 18 dollars a night. Built like a Swiss chalet, it boasted all the curlicues and pillars of such structures, and even the lace curtains had little Swiss figures dancing on them. We had supper at the restaurant – chips and B.B.Q. chicken – and possibly due to my starved state, it was ambrosia! But I've been mistaken before when extra hungry – if hungry enough, even cold porridge could see me raving. As we ate, the waiter popped a Billy Graham video on – but the English was all dubbed out and replaced with Swahili – I was in Africa now! But I had watched enough Billy Graham specials, I knew exactly what he was saying. The mosquitos were dreadful that evening, so Johnson walked to a *duka* for spray. Then after dousing each room to fog-like proportions, we all slipped into Johnson and Roza's room for *chai* and a visit.

One subject I hadn't broached to Roza was about African people asking for things. Not the actual beggars on the street – this never bothered me – but rather, housegirls and such asking for my watch, my shoes, makeup, camera or radio. This has always grated me.

"Oh, Betty, even I am asked for things!" Roza said. "They will even point to the *kanga* I am wearing and say 'I want that *kanga*'! I never give it to them; I know who the poor are and when they ask for help, they do it in a different, more acceptable, way, usually bringing something in exchange like beans or maize!"

Kilangala's policy is to never give clothes, etc. free – this will destroy the dignity of the poor. I had noticed in Dar, when the housegirls asked for my watch or something, and I said "No, then I won't have one!" they never took offense, but seemed rather to have expected it and there was no ill feeling whatever.

That night, I was bone weary from the trip, but after a good eight hours of undisturbed slumber, I awoke fresh and raring to go. Johnson went off on another safari, so Roza and I, with little Anneke, went downtown to shop. I, as usual, had to exchange money for my train trip to Dar and was pleasantly surprised to find no hassle whatever! I loved this new Tanzania! We wandered around, looking for African prints in all the *dukas* and then on to the market, which was bursting with color, noise and plastic junk, but alas, alas, not one piece of African art or weaving. My big thrill was finding a good, galvanized milk pail in a dusty little *duka*. Now the boys had a real pail to milk into! Next we stopped at Rajane's video store, where I was welcomed back like a favorite eccentric aunt. After a chat over the inevitable bottle of soda, they drove Roza back to the guest house to do some paper work she had to attend to, and I stayed for dinner with them. After an exchange of addresses, I was taken to the railway station for my ticket. I had travelled second class previously, which consists of six bunks to a compartment, but Mr. Rajane felt I would be more comfortable going first class.

"Hmm," I thought, "I'm not used to travelling first class – I might just have to iron my skirt for this trip!"

But so be it, a first-class ticket was bought for 12 000 shillings, which is very reasonable. As we drove out to the Karibuni Center, Firnz proudly told me of his son's academic achievements and he had reason to be proud – all A pluses. I paid a quick visit to the bookshop at the Karibuni Center, hoping to find some souvenirs, but only managed 2 pairs of salad servers – I was really having a hard time spending my money!

The power went off and the restaurant was closed at supper time, so we all piled into Roza and Johnson's room and lit a lamp. Roza, who always carries emergency supplies, knowing how unpredictable travel can be, unpacked a Chinese cooker exactly like the one I used to use. It's a round affair, with wicks all around the center plate; I used to have to cook a full meal on it at times when out of propane. That separates the amateurs from the old pros, let me tell you! Just as we finished a goodly snack, there was a tap on the door and in came Moses! The trip to Iringa had gone so well, they were back already.

"Oh, no," I thought, "Now I have to say good-bye again!"

The next morning was spent downtown collecting materials to take home to Kilangala, everything from galvanized roofing sheets to baby formula. We arrived at the station in good time. With Johnson leading, we marched out on to the platform, where he stopped with a flourish.

"Mama Betty, the first class carriage will stop right here!" as he pointed with his size twelve foot. And it did – right on the spot.

I was hustled aboard and into my compartment, where three Tanzanian women were settling in. After more good-byes – I hate good-byes – off they went, turning to wave before heading out on their long journey home, which with luck they would reach in about four hours. My fellow travelers were chuckling and whispering in Swahili, as I tried in vain to hold back my tears. I knew I would miss my friends, but mixed in

with the sadness of parting was a sense of elation as well. I had actually completed my safari to the back of beyond and so far, had come out unscathed. I was thankful Firnz had persuaded me to go first class. It definitely was more comfortable, with its softer seats and roominess. I grabbed a lower bunk and rather sheepishly explained that I could probably climb up to the upper bunk, but they would definitely have to haul me down!

As we settled in for the long train journey back to Dar, I sat musing as one does after such a journey. I had only known Moses, Roza and the others for two weeks, and Johnson scarcely more, so why did I feel this affinity with them? Possibly because it was such an intense period of questions asked and answered, problems solved and more to attend to when I got home. I learned so much this visit and felt quite content as the train trundled on. I introduced myself to my roommates, two sisters and an aunt all heading for Dar. At the very first whistle stop, they bought a basket of potatoes from a vendor on the platform and, in order to give his basket back, dumped them on the floor, red dust flying. I thought, you can take the girl to the city, but there's always an element of village still in her heart.

I gazed out the window, watching the African countryside slip by. The *shambas*, which were brown and dry when I passed two weeks ago, now were greening up, smoke from the cooking fires was spiralling up, children's joyful laughter. I absorbed it all, knowing my safari was nearing its end. I wonder, did Karen Blixen see what I saw – did she see with eyes like mine – or Speke and Burton – did they view the people as fellow human beings, as God's creations, or as something to change and commercialize? I couldn't help but ponder, why, oh, why, do I always feel called back to this country? Will I ever know? Am I so different? Did others feel this tremendous inner urge or did they just wish to explore – what called them? All that philosophizing left me hungry, so I was glad when supper was announced! As we ate, the elder sister asked me my age.

"Here we go again," I thought, "What's this about age in this country?" So I felt she had opened the door for my questions. I learned she was 36 and had never been married.

"Many girls are like me now," she explained, "but it took me three months to find a job when I moved to Dar, and the wages are very low, but it's worth it!"

"Would you advise other girls to remain single," I asked, "and try for jobs or further their education?"

"Most definitely," she said with fervor, "If you marry young, you will be just another village wife – a second class citizen!" Her younger sister was going to Dar to try and find work, but the aunt, I was told, was a traditional Tanzanian, which I took to mean just a housewife. As the ladies settled down to sleep, I popped three Gravol – trains have always brought on motion sickness in me – and went off to dreamland, not even waking at the whistle stops.

Early the next morning, we travelled through the Selous Game Reserve, touted as being the largest game reserve in the world. Named after Frederick Courtenay Selous, an English "white hunter" of the late 1800s and early 1900s. Frederick Selous was larger than life, a cross between the perfect English gentleman and Buffalo Bill. He was an ardent naturalist and a prolific writer. Nearly every white hunter who knew him claimed he was the very finest hunter and naturalist ever to travel in Africa. His brother claimed he was born with an elemental determination to live an outdoor life in Africa. At boarding school, he slept on the bare floor every night and when asked why, he said with determination, "I am going to be a hunter in Africa and I am just hardening my body for sleeping on the ground." He continually slid down a rope from his dorm window to foray into the night, collecting creatures to study, and as a result had some quite amazing run-ins with angry gamekeepers. Selous hunted with presidents and earls, all of whom lauded him with honor. Author Rider Haggard used Selous as a model for the hero of his book, *King Solomon's Mines*, Allen Quartermaine. While still an active, energetic man in his sixties, Selous was serving in the

British Army and was shot while spying on the Germans. His body was sewn into an army blanket and buried on the spot he died, in the northern part of the reserve which is named after him. A simple slab of cement marks the grave.

Through the mist I could see giraffe, impala, a few zebra and many warthogs trotting about. Those little fellows brought back memories of when I was enlisted by the workmen at Uvinza, when Bill was too busy to go out and shoot some meat. The warthog was the only animal I was sure of hitting, as I'm not great at leading with a gun. This meat was good, very like our pork, only the fat was marbled all through it, so it was very tender – with green mango sauce, it was a meal fit for the fussiest palate.

The Ragged Edge of Disaster

On arriving in Dar, the three ladies offered to share a taxi with me into town. But the driver didn't have a clue where the Flamingo hotel was – a common problem with taxi drivers in Dar. Of course, if the hotel boasted a sign, it would have helped. But after a few detours, we pulled up in front of it. My trip upcountry was over. Now I could just relax, shop and prepare for my flight home. As the little taxi driver struggled to lift my suitcase out of the trunk, along came Sultan.

"Betty Aunty, it is good to see you once more!"

"And you, Sultan – how was your safari to India?"

"Oh, Aunty – it is good to be home – India, it is very hot, very dirty and very expensive!"

"Yes, my friend, it is always good to arrive home!"

Then Sultan asked me a strange question.

"By the way, have you seen your daughters?"

This particular question didn't surprise me overmuch, as there are several girls in Tanzania who call me Mama; I just had to figure out which ones they were.

Pondering, I asked Sultan, "Is it Joyce from Kongwa?"

"No, Mama – your daughters," Sultan insisted, "Your Canadian daughters!"

"Oh, ya sure, Sultan!" thinking he was teasing me, as he loved to do.

"No!! Really – I'll take you to them!!" He insisted. "They are staying at the Skyway hotel!"

"Oh mercy," I thought, "the Skyway – some of my daughters would have some culture shock if they arrived at the Skyway!"

True, it was the hotel Beth and I often stayed at when we came to Dar, but that was after we had been in the country for a while and were well broken in.

As we drove over to the Skyway, I quizzed Sultan, but all he said was, "You'll see, Betty Aunty – be patient!"

On arriving, I asked the clerk, "Do you have two Canadian women staying here?"

"Yes, yes," the man said, "they left last night, but they left a note for you!" and handed me a note in Judy's handwriting.

"We are at the AGIP hotel – Come Soon!"

Heavens – and who was the other part of "we"? So over we go, as fast as the traffic would allow. I should explain; the AGIP hotel, though not the absolute most expensive, was the very nicest hotel to stay in, and the poor old Skyway was rough, seedy and the gathering spot for prostitutes. Beth and I had stayed there because it was cheap, but Judy? I asked for their room number and phoned up from the lobby, not knowing who or what to expect. After that, all I remember was the phone being lifted, and an almighty shriek – "It's Mom – she's HERE!" deafening me for two hours. I practically ran up the steps, Sultan coming along behind at a more dignified pace, and there was Beth running towards me, arms outstretched. To say it was a surprise, a lovely, lovely surprise, would be putting it mildly, but here they were! They had decided on the spur of the moment, after I had left, to fly over and surprise me in Dar – I was just so thankful I had come back as soon as I did and not gone on another safari from Kilangala.

After we had finished all the weeping and hugging we seem to be famous for, I learned with horror that Judy had been mugged! After arriving and settling in, they had decided to go for a walk, and two thieves had run up behind them, kicked the backs of their knees out from under them and stole Judy's fanny pack with her passport, credit cards and some traveller's checks in it. In the ensuing scuffle, which in itself was terrifying, her hand got twisted, leaving one finger very swollen and painful. I could see she was in a state of shock – although usually a very calm, collected person, no sleep, jet lag, plus this horrifying incident had used all the reserves she had. So Sultan and I bundled them into his car and brought them home to his place.

I can't adequately describe the love for humanity this family has – no matter what color or creed, they open their home and hearts to them. Back in Canada, I've seen, face to face, prejudice of all sorts, but the saddest of all is the prejudice some so-called Christians hold toward people of other religions, and even of people of other Christian churches. I hate this "holier than thou" attitude. I cannot believe Jesus would approve of this. I have read that division amongst churches has done more to hide Christ from man than all else combined. And we are not to judge – leave that to God. I've read hundreds of books by and on missionaries, and one man seemed to stand out in this area. I feel he is a real example of what we should be doing. Viggo Olsen is the subject of the book, *Dactar*. He established a remarkable medical mission in Bangladesh, working with people of several faiths. While never compromising his own, he accepted and loved all people – they were his friends.

The Jiwas are Ismailis, but believe me, we Christians could learn a lesson from them. On the Sunday we spent with them, Sultan ordered us to go to church and he took us and dropped us off. We couldn't find the little Presbyterian Church I knew was in Dar, so we ended up at a huge Catholic Church. We knew little of the Order of Service, and it being all in Swahili rather cramped it for us, but I can't forget the experience and have wondered more than once if we would have driven a

Moslem friend to a mosque, if he wished. After the service, we sat at home, discussing our problems. How to get a new passport, cancel the traveller's checks and find a qualified doctor to treat Judy's hand – all in a week! It seemed insurmountable. But Sultan, who was listening to us going round and round and getting nowhere, took charge. Pulling himself up to his full height, he stuck out his chin.

"Listen, stop worrying, Betty is my Aunty, and you are my nieces, so Uncle will solve it all – remember, I am a SULTAN!" We sat there amazed as Yasmin, with a great smile, patted Judy on the back.

"He will too, don't worry!"

After supper and a drive along by Oyster Bay, we stopped for ice cream and dropped the girls off with a promise to pick them up early next morning. As I settled into my bed, I heaved a great sigh – my return to Dar, which I thought would be rather mundane, proved once more that you can always expect the unexpected in Africa. I was up early, and we picked the girls up at 8 and started one of the busiest days I had so far on this trip. Sultan and Yasmin are a well-known, well-respected family, and have an inside track to many businesses and members of the professional community in Dar, so it was no great surprise when Sultan pulled off an impossible move – getting an appointment with possibly the very best doctor in all of Dar. Dr. Kessi, who teaches medicine as well as practising, saw us in the hospital. Judy, still extremely nervous, jumped each time he even looked closely at her finger, because it was so painful if touched. Dr. Kessi sensed this, so smiling gently, he said it was not broken, but rather, just out of joint, and after an x-ray his colleague would set it. I noticed Judy's look of panic, but before I could say anything, Sultan took charge.

"No, Doctor, you are the professional who teaches – we want you!"

Dr. Kessi just sighed and said, "Okay, okay, I'll set it this afternoon at four!"

I had to hold back the urge to jump up and kiss the man, so instead I just thanked him with as much dignity as I could muster at the moment. So off to x-ray – Judy and Sultan, with me hovering like a mother hen protecting her chick, Beth trying to keep us all sane. The poor technician had to not only deal with a nervous patient, but also a basket case of a mother. Each time he went to move her finger, she'd gasp and I'd swat at his hand. If anyone ever tries to tell you your mothering instincts disappear when your child leaves home, don't believe it! It just deepens and turns mothers into blithering idiots. The x-ray proved the doctor's diagnosis, out of joint at the middle knuckle of the right hand, which was a bit of a worry, as computers play a big part in Judy's career.

We figured we had time to pay a visit to the Canadian Embassy before the doctor's appointment, so Sultan went back to his restaurant to catch up on his work, while we took a taxi to the Embassy, a huge, modern, sprawling complex set in immaculate grounds. It was so humid and hot, we were all dripping, so it was lovely to be received in a cool comfortable office where we were met with great courtesy. Robert Cullen, the Attaché, was kindness personified, and his quiet demeanor was meant to put Judy, Beth and I at ease, but between the three of us, he must have figured he was meeting with a family of happy lunatics! Judy was so nervous, when he leaned over to pat her hand, she jerked back with a snarl like a hurt puppy; Beth was going the extra mile with over-the-wall cheeriness; and I, trying to shake my wet hair off my face, caught my big hoop of an earring and shot it past the poor fellow's face onto the carpet behind him, where I had to crawl on my hands and knees to retrieve it. He told us he had lived in Dar for two years and understood the situation. He told Judy not to feel too badly, he saw people just like her every week, in various forms of distress.

"In fact, you got off relatively lucky!" he said in a sombre tone, "I've even had white women in who had been robbed not only of their purses, but also clothes and glasses! You should never venture out unless with a group."

I didn't feel this was the moment to tell him I had just travelled all the way across Tanzania and back again by myself! Strange, maybe, but I never felt any fear, neither on the safari or in Dar itself. Possibly this was due to ignorance, I don't know. I did wear old clothes – long loose shirts, cotton skirts and thongs. I took off my earrings and never wore a watch, so I looked like anything but a wealthy tourist. My hair, which fuzzed out like a halo in the humid air, had turned an alarming orange color from the minerals in the water, and I told all and sundry I was going to Sumbawanga to meet my friends. Maybe the thieves thought I was a witch – I at least looked a bit eccentric – whatever it was, I had no trouble whatever. As we sat and chatted, he mentioned he never goes downtown, they stay strictly in the compound.

"Dar is very dangerous!" he stated.

A lot of their needs and wants are shipped from Canada, and their houseboy goes to the market, which he claimed was the second most dangerous place, the beaches being the first. He told Judy he could easily get her another passport and health card, and if need be, could even get her some funds.

"The Canadian government is usually reluctant to hand out money, but will certainly do so if the need arises!" he said rather proudly.

With the economy the way it is, they have reduced staff and were planning to rent out the bottom floor. The "Bill" in me wanted to ask why they left the old Embassy, where we used to go for our gamma globulin shots while we lived there, or why didn't they just build a smaller, basic one. But for the moment we couldn't have cared less. We and all troubled Canadian tourists wanted help, comfort and sanctuary in familiar surroundings. I was never so glad in my life to be able to go to a Canadian Embassy. The plans were set in motion for the new passport and health card, and we arrived back at Sultan's feeling positively giddy with relief. Fayez picked us up to take us over to the Gulf Air offices, as we had decided to try and change my booking to coincide with the girls'. We felt that after this fuss, it would be nice to fly home together.

Fayez has great charm, which he turned full force on the office girls, and we had the new ticket before those girls knew what hit them. Another obstacle overcome. Then it was time to go to the hospital to have Judy's finger set, not something any of us relished, but Sultan was a pillar of strength. Dr. Kessi awaited us in his office, his very attitude exuding confidence, but not enough to assure me.

"You do use a new syringe!"

"But of course!" he answered quietly as he painted something on her finger.

"What is that?" I asked, only an octave higher.

"Iodine," he said with just a trace of a sigh.

"And that?"

"Rubbing alcohol," he said with a mutter.

In fact, on looking back, I believe he answered all the questions like he felt I was quite mad! Then the hand-holding; Judy had quite a good grip on me, but the one I was using on Judy was so strong, it's a minor miracle the poor doctor didn't have to set her other hand as well. We sat a moment chatting, while the freezing took effect, and I asked him if he was any relation to the other Dr. Kessy, the young vet I had met. No, he wasn't, but he had heard of him and they were both from the Chagga tribe.

Once the freezing took effect the doctor easily manipulated the joint back in place, and before Judy knew what had happened, she was bending it easily. A little splint and some pain killers and we were done. I stopped to thank him profusely and he said, "I wasn't too worried about the patient, but I wasn't all that sure about her mother!"

Arriving back at the Jiwas', I thought Judy should take a couple of pain killers before the freezing came out, so I handed her two. The doctor, possibly thinking we were all physical and mental basket cases, had prescribed extremely strong ones, which sent Judy into la-la-land for a good 24 hours! The

next morning I went over to the Agip and Judy was her old self again – almost – so we decided to walk a couple of blocks to a drug store for an elastic bandage, as the one the doctor had wrapped on wasn't holding very well. But Judy was very nervous due to her accident and the streets in Dar can be very crowded, so with Judy between us, expecting muggers behind her with each step, Beth ran interference in the front and I brought up the rear guard. Even so, this was one of the hardest walks Judy ever took.

We were to go back to Sultan's for lunch at one, so we got a taxi, asking first if he knew where the Flamingo hotel was – oh, sure he knew – Ha! We drove about all over the city, through some amazing back alleys and side streets, until we finally gave up and told the driver to take us back to the Agip where we tried to phone Sultan, but couldn't get through. Finally, giving up, we ate lunch and discussed our dilemma. Beth was sure the head housekeeper, who she had visited with, would be able to help us.

"Don't worry," he said with a delightful smile, "I know a cabby who will take you there with no problem." But even with this older driver, we had to circle about and go down an alley or two before we found the Flamingo. There are no house numbers, with all mail going to the post office, so places are very hard to find. To top it all off, the Flamingo hotel sits there without a single sign to be seen. So a great deal of time was spent wandering around Dar with puzzled looks on our faces. When we arrived, Bobby walked us home and Sultan immediately sat us down like errant school girls and went over and over the accepted route, and what to tell the taxi drivers. He held little hope for me – even when he drove me right to the Agip, if he parked at a different corner, I'd get out and wander about, wondering where the hotel was even though it was directly in front of me. I always tried to cover this bewilderment, but the next time I saw Sultan, he'd say, "You were lost this morning."

"Me lost? no way," I'd bluff.

"Yes, you were!" and off he'd go, grinning knowingly.

Of course, he didn't need to know I've been known to get lost in the downtown Hudson Bay store in Calgary! But the girls can always find me – either by listening for my whistling or smelling the perfume samples I always try out! Our evenings were spent with the Jiwa family, playing Monopoly, helping Rahim with his homework, watching videos or visiting, visiting, visiting, as we knew we would soon be leaving and who knows when we would see these dear ones again. Not one evening went by that we weren't stuffed to the brim, Sultan and Yasmin bringing out chocolates, roasted cashews, soda – even Chinese chewing gum. We felt a bit like spoilt fat cats, so the weight I had lost on my safari upcountry was easing back with great rapidity, like a rogue wave sweeping the shore. Our days were filled with rushing here and there trying to get Judy's documents replaced. Each day we encountered more and more delays. One obstacle was trying to get another passport photo. For days on end, we were on a veritable merry-go-round.

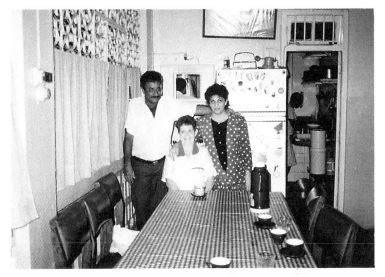

Sultan, Betty and Yasmin.

By this time I was in total awe of Robert Cullen and his Canadian Embassy – he was right up there, slightly lower than God, but giving the Pope a good run for his money. No one

who has never had need of an Embassy can imagine the haven they are when you need help in a foreign country. It's a security blanket. I could hardly believe it when I heard myself stating, "Cut back wherever, but leave our Embassy alone!!" Robert – we were now on a first name basis – was always so helpful and we all enjoyed many chats between our whining about passports, thieves, etc. He had had so many different postings in various countries, he rather felt he had no real home. He and his wife like the perks, like being able to take their pets with them, but I feel they earn every single one. He was working in Jordan when the Gulf War broke out, and his wife was immediately sent home for the duration of the crisis. While driving to and from his office each day, he had to radio his position each block and all the windowpanes in his building were covered to prevent shattering during explosions. There were rumors that chemical warfare was a distinct possibility, so they placed wet towels under each door. It was a very touchy, dangerous time.

We always looked forward to a visit at the Embassy and their friendly staff. On one occasion, we were about to call for a taxi to take us back to the Agip, but Robert stood up from behind his desk.

"Oh, never mind, I like to get out of here once in a while!" and off we went in one of the vehicles, Canadian flag waving on the hood. My, we were proud!

Finally, we managed to make an appointment for the photo session for the passport picture. We arrived ahead of time at a funny little studio, with all sorts of extension cords, some distinctly frayed, running along the floor in all directions to wall units. What rather startled me was the fact that several of them trailed through great puddles of water lying here and there on the floor. We had recently had a very heavy rain shower and the old building leaked, but not a soul seemed the least perturbed, so I figured, why should I? When we took the photos to the powers-that-be, we were told they were too small, so we had to have them enlarged, which would take another four hours and also more shillings – which, by that

time, didn't surprise us one bit. But while we were untangling all that red tape, we still had time for fun and frolic.

One day while sitting about in the girl's hotel room, we decided we'd cook and serve a real Canadian supper for our friends – not one of our brighter ideas. The menu was to be chicken, mashed potatoes, salad and custard pudding. For some strange reason, I had packed a great box of Crispy Shake and Bake in my suitcase, thinking it might be a treat.

"Yes, we can handle this – no sweat," I told the girls with great confidence.

I could just see the various dishes set out on the dining table in all their glory. Heck, I might even pick a small bouquet of flowers for the centrepiece. I just couldn't wait to get started and we immediately planned our strategy. Now, to buy a chicken in Dar, you do not go to a supermarket and pick up two packages of cut-up chicken pieces, all done up in plastic. No, you go to the market and haggle. So Judy thought she could handle that purchase. After all, she thought the chickens would be butchered and hanging on a line and she would just pick out the three she wanted – with Sultan's help, of course! Actually, we couldn't even put the supper on without their help! So off she went, hanging on for dear life, with Sultan on the motorbike.

The open-air market was crowded as usual, but to her horror, instead of picking out three dead chickens, she was escorted into a dark little *duka*, stinking to high heaven of chicken manure. The worst part was, Judy has a very strong phobia about birds, especially live ones, so when the proprietor lifted up a live chicken, squawking and flapping its wings, for her inspection, she had to dig a deep hole in her soul for reserve cool or she'd have gone screeching out of there. Finally, she picked out three – by that time she didn't care how much meat they had on their bones – and the necks were wrung and the birds handed to Judy with a flourish. Who cleaned them, I never found out, but soon they were presented to me – the great chef!

Meanwhile, Beth and I had gone shopping for the rest of the ingredients, salad dressing, margarine, custard powder, fruit, etc., and on returning I took over the kitchen like I knew what I was doing. After all, back home in Canada, I can bake biscuits to "die for," I bragged to Marta as she worriedly flitted about me. As I worked in the margarine, I realized I hadn't taken into consideration the possibility that the ingredients available in Dar might be different from those I was used to, and I didn't know the stove – a cook's worst nightmare! The flour felt very different and didn't seem to have the same consistency as I was used to – but, I was in too deep to back out now. They did not look too appetizing as I placed them in the little oven, and I was hoping fervently they would improve with the baking.

By the time Beth started the pudding, the kitchen was so hot you practically didn't need an oven. Scared she'd scorch the bottom, she stirred and stirred, the sweat running off her face and down her back and shoulders, like she was in a sauna. Marta, taking pity on her, grabbed her long hair and knotted it up on top of her head, wiping off her neck. But even when Marta turned the heat up higher, that custard pudding wouldn't thicken, so she ended up pouring it into the dishes, hoping it would set as it cooled, but how can anything set at 38° C with 100 percent humidity? I plastered the chicken pieces in Shake and Bake and in the oven they went. By now we were all wishing we had never thought up such a ridiculous idea. How could we ever cook a meal which would even come close to the ones we had been enjoying? I knew, without a shadow of a doubt, by the time everything was cooked, that we had a major disaster on our hands.

I tried to warn Yasmin, but all she would say was, "Oh, no, Aunty, it will be wonderful – we are all looking forward to it!" and she patted my arm as she went off to check on Rahim.

The whole supper was even worse than we could have imagined. The chicken was tough and stringy, the biscuits gun-metal grey globs and the pudding thinner, if anything. The only edible foods were the potatoes and the salad, and

even the salad dressing must have been on the shelf since confederation. But through it all, the family was gracious, raving about the mess in front of them. Even when a chunk of biscuit stuck in his throat, Sultan bravely squeaked out praise while trying to dislodge the horrible lump. They were so kind, it was absolutely pitiful – even asking for the biscuit recipe! I've heard of the Last Supper – but the disciples enjoyed that and we didn't even have wine to wash away the taste! All in all, it was one hilarious disaster! I must add, in conclusion, that from 9 o'clock on that evening, the fridge was raided several times.

Mama, Madman and More

Time was really zipping by and we wanted to do something nice for the whole family before we flew out, so we decided to ask them out for a dinner at the AGIP as a small thank-you gesture. The night chosen happened to be Beth's birthday, so Judy and I decided to surprise her as well. During the day, we went to finish off our shopping for those at home, ending up at the Kilimanjaro hotel. This hotel was the classiest and best in Dar some 20 years ago, and so expensive only moneyed tourists and government officials could afford it, so I was surprised to find it rather seedy-looking now, not nearly as nice as the Agip. We were very pleased to find lots of neat little gifts at reasonable prices. Not knowing what on earth to bring Bill, I ended up getting a beautifully-engraved cane. We were almost smug as we headed back to the hotel.

I still had to find a birthday gift for Beth, so Judy took her upstairs under some pretence or other, and I flew to the taxi stand and asked one fellow where I could buy a bouquet of flowers. By this time, all the drivers knew us and didn't expect much in the way of dignity and common sense, but lots in the way of hilarity.

"Yes Mama, come, I'll escort you there!"

Off we went, the old taxi shaking and groaning, African rock-and-roll bellowing out the open windows. After two or three stops, we finally found a tiny shop on the outskirts of

Dar, where I was thrilled to find a basket of ten roses for five dollars Canadian. We tore back to the hotel, where I gave them to the waiter in great secrecy, with orders to place them on our table that night.

Meanwhile, the Jiwas, figuring the dinner was only in Beth's honor, had somehow managed to make a beautifully iced birthday cake after 12 that day. That evening was so special. The Jiwas all arrived together, looking spectacular, not hard for them as they are all extremely good-looking. Even little Rahim was decked out in a regular safari suit. After a joyous supper, we all retired to the girls' room where we enjoyed the birthday cake, shoes off, sprawling on the beds. Then Sultan presented Beth with gold earrings and popped another piece of cake in her mouth, to her great surprise. We learned that this is a tradition at Ismaili birthday parties – each

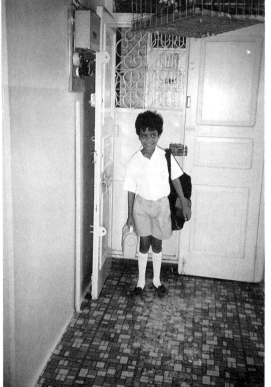

guest presents a gift and feeds the recipient a piece of cake! Needless to say, Beth felt just a bit stuffed by the end of the memorable evening.

Rahim, the Jiwas' youngest child, is a joy to all, absolutely adorable. One look at that smile and you're his slave forever. But Rahim has a condition called Thelesemia, which is a constant worry for his family, which is quite un-

Rahim – a little delight.

derstandable. This condition, very common within the Asian community, is rather like sickle-cell anaemia, only the red blood cells are of a reduced size, with less iron, thus carrying less oxygen. He has had his pancreas removed to help control the condition, but everyone hopes he will grow stronger with time. Now 12, he has been diagnosed for several years. Rahim has been seen by the top doctors in this field in London, England, and the family was in India seeing specialists when I arrived in Dar. They nearly lost Rahim the fall before, having had to charter a plane to fly him to Nairobi for emergency treatment. Presently he is on medicine which is administered by slow injection over a 12-hour period, his Dad setting it up. You can just see the gigantic boulder of pain on Sultan's shoulders. While we were there, Rahim needed blood transfusions, a procedure which takes days to set up. Safe blood has to be found, usually from relatives and friends with the proper blood type and no danger of AIDS, then they have to be transported to the hospital. Then all blood cells have to be washed out before the actual transfusion, all accomplished African time. But the Jiwas keep praying for a miracle, not unlike parents all over the world.

Most mornings I took it a little easy, spending my time writing notes, ironing or whatever needed doing. As anyone who knows me will attest, I'm a chronic, addicted, whistler. I am always whistling, many times without realizing I'm doing it. I've heard lots of remarks, gotten many strange looks and the odd bit of head shaking over this addiction, but the strangest thing happened on this trip. One morning as I was doing my nails, I heard someone whistling – and more than that, he was whistling an Irish folk melody! Wow! I went running to the door and peeked out, thinking I had company. But not a soul to be seen. Giving my head a shake, I sat back down, thinking I must have been hearing things. But a minute later, I heard it again. This time I knew the melody – I should know it, I had been whistling it for years! I jumped up and ran to the window, but it had stopped. I was beginning to think I might have been whistling it myself – but I knew different. When it started again, I sat very still and peeked over my shoulder. Lifting my eyes cautiously as the whistling went on, I realized

with amazement that it was the pet Grey Parrot – I had taught it to whistle! I couldn't wait to tell the girls, but when I did, they just snorted, "Oh sure, Mom." But eventually they also heard the great recital of the "Wild Colonial Boy"! I can't help but wonder if it still can whistle the tune?

The Jiwas' home is a very busy place, with lots of interesting people in and out every day. One time Anil Khamis, a young Ismaili religious education teacher, arrived for dinner. He had only been in Dar for a few days and the heat and food were getting to him, so he asked Sultan if he could eat a meal with them, thinking a home-cooked meal might help him settle in. It did, too. Yasmin's cooking has that effect on people, although I think the homey friendliness of the family also played a big part in his recovery. I learned he had grown up in Scarborough, Ontario, but had studied for several years in London, England. I asked if he was just going to instruct in Dar.

"No, Mama, I'm to go to the far reaches of the country – even Sumbawanga!"

It always amuses me to hear from so many that poor old Sumbawanga is as far away from everywhere as you can get! When I stop to think about it, I realize: yes, it is! A few days later we ran into Anil at the Flamingo restaurant, fully recovered, relaxed and happy, and we were greeted as old friends.

Judy, Beth and I often stopped in at Yasmin's salon on our way by for a quick visit, and to see what was going on. One day, I was sitting near the dryers, chatting away, when all of a sudden a weird-looking Tanzanian man, with wild, rolling eyes and a spastic shake to his hands, slipped in and turned, shut the door and locked it. I was so busy looking him over, wondering what he wanted, that I failed to notice every other soul in the place, including my own two girls, scrambled over one another to get into the back room, and on shutting the door, started screaming their heads off.

"What is going on here?" I pondered.

The poor man was right out of it, pacing back and forth past my knees as I sat there. I could see all the others, still screeching and hauling bits of furniture to support the glass door they were behind. Then it hit me – I was locked in with a madman, a mental case. He kept dashing back and forth, getting more upset with each step, muttering and drooling all the while – and my own girls were shouldered against the door, so I couldn't have escaped in there if I had wanted to. My own daughters had left their mother in a time of crisis! But I didn't feel I was in any real danger – after all, I had that ten-ton purse I could slug him with if the need arose, or I could yell at him like I used to do with the kids, a yell that could stop a mad bull in mid-stride, I've been told. But all of a sudden, in roars Sultan, opening the door with a spare key. My, his anger was magnificent! He hauled the poor bewildered fellow away and came back to check if we were all still in one piece. As all the girls sheepishly crept back in the room, mine with them, they had trouble looking up, and my girls couldn't look their mother in the eye. This was most interesting!

After much discussion, we found out one of the hairdressers had been teasing and tormenting the man, and he had stormed in to get even. Of course, the girls and I were indulging in hysterical laughter by this time and it took Sultan five minutes to get our attention.

"If you can control yourselves, I'll take you to the gold shops now!"

There was dead silence before he finished this sentence – the hope of a shopping trip has this effect on us. I wanted to get rings for all my girls and some earrings for myself. Tanzanian gold is of excellent quality, and people travel to Tanzania from all parts of the world to purchase gold. On the way to the shops, Sultan instructed us to look everything over carefully, pick out what we wanted and let him do the dealing, and this is what we did at first. The girls got excellent buys and the rings I picked out were purchased at a very reasonable price, with Sultan doing the upscale-style bartering. But when it came to my earrings, I thought I might try and help Sultan

out – he seemed to be having trouble with the fellow and I felt I should just put in a word or two. I still hadn't mastered the art of bartering, but that didn't stop me from trying.

"Please, that is just too much – we are poor Canadian farmers!" I stated. Then the coup de grace, "You must realize, I'm a very old woman and won't live long enough to really enjoy them!"

I thought this statement a brilliant stroke of genius. On the way home, I was bragging about my great skill, when Sultan said, "Betty Aunty, I had the price lower than what you ended up paying when you burst in like that!"

"What a day!" I thought as I sat in the living room, my shoes kicked off. But there was yet another little turn ahead. Fayez sauntered in with a big smile, stating he had heard something very interesting! Knowing Fayez, this could definitely be anything!

"I was chatting with a taxi driver today and he told me he had heard about the white Mama staying at the Jiwas'. He had heard on a radio broadcast that the Canadian woman who helps provide blankets and other needy materials for orphans was holidaying in Tanzania! Yes, Betty Aunty, you are very famous!" Fayez sang as he skipped about the room. All I could think was, they were awfully short of news! But the day wasn't over: Bobby had hired an Indian artist to apply the beautiful scroll painting all Indian brides cherish, on Beth and Judy's hands. It looked very elegant and mysterious, all done in henna, and they had to protect it until it thoroughly dried, 12 hours later.

The next day, we were all invited to a friend's home for a little boy's birthday party. Sultan ordered us all to dress to the hilt – I was even told what to wear.

"Wear that dress you wore at the hotel, Betty Aunty and Beth, wear your new earrings!"

He was going to show us off in all our glory, I gathered. On arriving, I felt the people were all very stilted, not the open

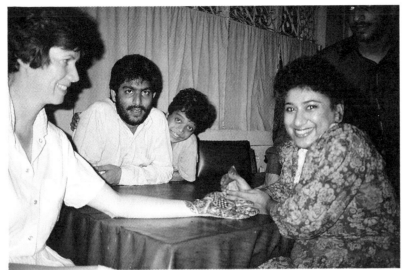

Judy (above) and Beth (below) getting the works – manicures and hand painting.

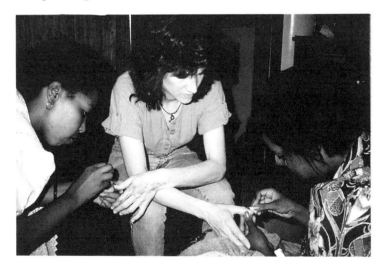

friendliness of the Jiwas. A few men sat around the room, flat against the wall on chairs, watching the video of the children at the party held a few hours earlier, and one man sat openly leering at the girls. The few Mamas in wonderful saris and tons of gold were busy in the kitchen setting out huge bowls of food, curries the likes I of which had never seen and all the

trimmings. But something was missing, I felt. There was very little visiting, even amongst themselves, and it took on the appearance of a poorly-staged show. It was with relief that we left to walk home in the wonderful African night, stars blazing overhead and the sounds and smells only found there.

The next day, I spent time sorting through my stuff, trying to figure out how I'd get everything in my suitcases. I had to maintain a cool, aloof manner with the younger housegirl, as she had started asking me for items, something I find very disturbing. I had already given her many little gifts and some money, but she didn't hesitate to beg for more. Marta, the older housegirl, who has been with the Jiwas for years, was different. A very attractive lady, about 40, Marta is married and has a family to support.

"Her husband is a big mean fellow, Betty, and he sleeps with other women," said Yasmin with a snort of disgust.

So it was with a great deal of pleasure that I left a gift of money and a little watch with Yasmin to give Marta after I had left. We had several small things we wanted to accomplish before we left, and one was to get pictures of Bobby making *paan*, known as Indian

Bobby making *paan*.

chewing gum. It's rather a unique treat and widely used by all people. It's a mixture of several ingredients, and you can buy either the hot or the sweet variety. Betel pepper vine leaves are laid out and filled with an assortment of fillings. Shredded betel nut, dry roasted dahl, anise seed, shredded coconut or, in their language, betel nut, *areca*, *catecha* and *sopari*. This is rolled in little packages of vine leaves and can be chewed for some time. Sometimes ingredients are used which are addictive and act as a drug. You can purchase these dainties in many coffee shops and restaurants, and Bobby keeps a fresh supply on hand each day.

As Fayez promised, the girls and I were the recipients of a full-scale treatment at the beauty salon, something we needed at this stage of our journey. It was fun, especially watching all the customers. Since the holiday season, Yasmin had hired several part-time beauticians, some trained and some just starting. Of every size and shape, these girls were all Tanzanians and practically all worked in their bare feet, a good idea as Dar was especially hot at the time. We got manicures, pedicures and hot oil treatments, all given in a novel fashion. For the manicure, we soaked our hands in a plastic hand basin, but the cuticle was ignored as this might be painful! They didn't scrape the dirt from under the nails, but they filed each nail to perfection. We had three choices of nail polish: brilliant red, purple and a pearly pink. For the pedicure, we stuck our dusty cracked feet into a plastic dish pan.

While we were in the throes of all this attention, we watched the girls pluck the eyebrows and chins of several East Indian women in the traditional way. A fine thread is held by teeth and fingers, buzzing in and out picking out the hairs with each buzz. If you remember threading a button so it's double, and gently pulling the thread back an forth like an accordion, it takes on a life of its own. It certainly wasn't a painless procedure, judging from the many winces on the faces of the customers. While Fayez was cutting my hair, I noticed my six weeks in Africa had tanned not only my arms and legs but also my face – it looked a bit weathered, not unlike an old glove.

But before I could start wondering where all the wrinkles came from, I told myself I looked healthy and let it slide.

Our week and a half in Dar was soon over, and although we had worried we'd never clear away all the red tape and get Judy's papers in order, we found we had everything finished with a day to spare. But that day proved very difficult and the family didn't make it any easier. Every one was walking around with sad eyes and little Rahim wept through most of it. Then Yasmin called the girls into the bedroom, where two huge suitcases lay open, spilling out beautiful Punjabi suits of every hue and color.

"Try each of them on and let me see," Yasmin ordered the girls and they did, every single one. As each one was tried and paraded Yasmin watched and when they were done, their favorite was presented to them as a gift.

"So you won't forget us when you are home in Canada," they were told.

I was presented with jewelry Sultan had brought back from India, and Yasmin gave me some beautiful Zanzibar jade. This whole affair was enough to start the weeping – and Kilgours are great weepers. By the time we arrived at the airport next afternoon for our long flight home, we were a red-eyed, drippy trio. We had no trouble with our suitcases, even though we had anticipated the usual hassle with customs. We were rid of them very quickly. Then we approached two lady police women, big, surly babes. I just wish I could tell the powers-that-be that the women they hire are power drunk and very rude to people. They very haughtily ordered us to open our purses and bags, disdainfully chucking our belongings to and fro. I was so glad to be through with them and was relieved to see the next counter was manned by three men, who were the exact opposite. Caring, friendly and professional, they helped us fill out our cards and on looking through my passport, they started to laugh.

"What is so funny?" I queried.

"Oh Mama, this Sumbawanga stamp!" and they broke out in gales of laughter once more. I knew Sumbawanga was in the backwoods, but really!

"Why, doesn't anyone ever go to Sumbawanga?" I asked, quite bewildered.

When they got their mirth under control, they explained, "No, no Mama, but you didn't need that stamp – you were still in Tanzania. Only if you go to Zambia do you need that stamp."

I told them that stamp had cost me about fifty Canadian dollars in bribes and they really cracked up.

It was so nice to just visit with them without a hassle, we lingered as long as we could, but eventually went off to wait for our boarding call with light hearts. But we had just relaxed upstairs, when the elder of the three men came slowly up the stairs and approached us with a very serious look. Oh boy, now what? He strode right up to me, stared at me for the longest minute I ever felt and with a flourish handed me my old, decrepit, torn glasses case I had inadvertently left on his counter. Then with a slight bow, he marched off! It was now our turn to crack up!

I hadn't been able to fit the cane I had bought so carefully for Bill into my suitcase, and was forced to carry it. I soon found a cane is not an easy thing to carry, especially when weighed down with a carry-on and a purse which weighed a ton. I found I was tripping myself, catching it on chairs and clipping the odd passer-by. But I was determined to get it home in one piece.

As we sat there, each wrapped in our own thoughts, I could hardly believe I was on my way home. Six weeks is a long time, even though it went so quickly. I was rather pleased with myself; I had accomplished most of what I had set out to do. I hadn't heard from Joyce, but all the rest had come together beautifully. I had rekindled old friendships and made wonderful new ones. Now I was eager to get home. I had left

Boxing Day and all my gifts were still piled on the dining room table – and mail – how I loved opening mail!

As I gazed about me, I noticed many African people of all ages, dozing on chairs and stretched out on the floor, their baskets and boxes piled nearby. I was told they were refugees with no place to stay. During the Rwanda-Burundi massacres, Tanzania opened the largest refugee camp ever in Northern Tanzania, and Tanzania is known for its humanitarian attitude concerning refugees.

Once on Gulf Airlines en route to Muscat, we settled in for the long flight. The aircraft was packed. We were practically the only whites on board, except one stewardess with a broad Scottish accent, no less.

"I'll bet there's a story there!" I thought.

The other two stewards were Asian men – one with an amazing toupee. The whole Aircraft was filled with silk saris of every hue and some marvellous white turbans – one so high, I figured the fellow must be a chef! We were seated quite close together, so we were able to chat back and forth, but after supper we each dozed off.

I was so looking forward to seeing Muscat, if only the airport. We arrived around 11 p.m., groggy and disoriented. The airport was bright and spotless, with a sense of quiet efficiency. I struggled behind the girls, wearing a long cotton skirt which tripped me now and then, lugging my purse and carry-on and that blasted cane, which by now had taken on a life of its own, causing untold misery. As we struggled towards some seats, I whacked a passing policeman in the shins, who gazed back with a dignified, "Pardon me, Madam!" I was the one who should have been asking for pardon, but was too tired to bother.

There were very few whites in the waiting room, especially women. The Arab women seemed to be all huddled together a few seats back, and we found ourselves surrounded by Arab men – quite a nice position to be in, I thought. They sat there, dark, handsome and brooding, all in Arab gear, their blankets

thrown over their shoulders. Thoughts of Laurence of Arabia came to mind. The girls wandered off to have a look in the immense duty-free shop and I sat back. I noticed all the men in the area were staring my way, not rudely, just very curious. Soon two of them wandered over and sat across from me. Finally one of them got up the nerve to speak.

"Good evening, where are you going?" he queried, and off I went like my tongue had been shot from a sling. We had a great chat and when their flight was called, they left with a soft good-bye and gentle smile. At 2:45, our flight was called and we tottered on to the plane, me snagging all and sundry with my cane. After sitting on the airfield for what seemed like an hour, a pilot came on, stating we were waiting for passengers evacuated from another plane after a bomb scare. But we were so weary, we didn't bat an eye at this news.

On this flight we had a belligerent passenger sitting behind us, shouting orders to the stewardesses before take-off. One young East Indian rose to help an old lady lift her bag up to the lockers and the noisy fellow bellowed out abuse.

"Hey, watch what you are doing – that's my luggage, you know!"

This was only the beginning, as with each drink, he got more maudlin and abusive. His seat mate, a chap from Alberta, walked the aisle to get some peace and as he passed us, leaned over to whisper, "How do you like my seat mate from hell?" This started us on another merry jag of giggling, so by the time we got to Gatwick, we were blithering idiots. By the time we caught the bus to Heathrow, both me and my bags were sagging and the cane delighted in catching everyone within a five mile radius. In fact, it was so bad, I poked it down between the seats on the bus to get rid of it, but when we got off the driver came running up to me.

"Madam, your cane!"

I could have whacked him with it. There I was stuck with this cane with a spirit. As we wandered Heathrow, I was trying to just let it hang from my arm, but no luck. Finally, I

ran my cart into Judy as the cane hit her ankle, and my gentle Judy snarked at me, her own mother! Her teeth were even bared!

"Watch where you're going and don't hit me again," she snarled.

Whoa, we were tired! As we passed a garbage can, I furtively laid the cane in it, walking away with a lighter step. But no, a young lady with alarming purple hair came running after me.

"Excuse me, excuse me – your cane, Madam!"

I didn't think to say it wasn't mine. This was worse than witchcraft! The thing possessed me!

Finally, our last flight was announced and as we walked to the gate I tossed the evil thing behind a potted plant and ran all the way to the gate. We arrived home safe and comparatively sound, all glad to get back to the wonderful loving welcome awaiting us.

Reflections

Since arriving home, I have had time to let my thoughts and feelings settle and simmer, sifting out the silt and polishing up the important parts. All in all, this trip was a challenge – but not one which overwhelmed me. I was accepted along the way as an amenable oddity and was allowed to fit, for a moment of time, in the lives of those I met on my journey, both physical and spiritual.

The Tanzania I saw was the same country I have grown to love, and is opening its arms to more and more business opportunities. A great deal of the mild hysteria of police and government is disappearing. I felt the country is moving to a peaceful and profitable future. I've been asked "How was it – living with blacks and Asians for six weeks?" I find this a distasteful question. What has skin color got to do with any-thing? I was delighted to make many new friends and very happy to visit with my old dear ones. I also can report, missions of all types are alive and well in Tanzania. They are growing and maturing, with the Tanzanians themselves in charge of many of their churches and missions. For each person who feels missions have no business in other cultures, I'd love to take you over to Kilangala and leave you there for a few weeks. I doubt many of us would change places with them, no matter how devout we think we are. You would come home with a completely different feeling.

Missionaries have been found to take over Katembo and Miss Beimers, after two serious illnesses, is now living at Kilangala in the home prepared for her and is immersed in her translation work. Moses is now the manager of Kilangala Mission, a position I know he will fill admirably.

Kilangala is still striving to become self-sufficient, so the greatest need now is for some basic machinery – a tractor, drill and cultivator.

The new isolation ward for the leprosy and T.B. patients is now complete and open. I did finish the ten blankets, and sufficient material was purchased and sheets and pillow cases were sewn and off by September of the same year. Whether Johnson or I won the bet, I haven't heard.

As I mentioned in my story, the situation at the orphanage at Katembo, where they were housing the overflow of babies in Miss Beimer's house, became desperate, and early the next year I got an SOS from Kilangala. Could I possibly raise enough funds for fifty new beds and provide blankets and sheets for the same? The mission was building the new orphanage! I know I could make fifty crib blankets and provide the sheets, but raising funds? I hate canvassing for funds, but felt I could stand a little embarrassment if it meant saving children's lives. I'm happy to say the funds, blankets and sheets were on their way within about seven months.

I might add here, I have now made and sent over 150 blankets of various sizes to the children and patients in Tanzania. These are made of odd colors of yarn, crocheted in granny squares and sewn together. My aim is for each child on the Wafipo plateau to be covered with a blanket. So if you see a rather haphazard, clashing rainbow in the eastern sky, you'll know I achieved my goal.

Of course, there's no end to the needs – I need several people to take on sending money on a steady basis to Roza to help buy formula. I can only manage ten dollars a month, but if there's enough small bits, it will achieve great results. I need some powers-that-be, in some exalted position with Kodak or

Fuji film, to donate enough film each year to be used by Moses to take school pictures for all the poor village children. You see, each child can go to school, but they must have a special card with their snap on it in order to set exams. The only photographer is in Sumbawanga and the villagers cannot afford him, so I sent Moses a camera and I try to keep him in enough black and white film to help each child. But there's hundreds of students in need, so it takes a lot of film!

All this, mixed in with the need for used clothes, material for school and for the ladies' sewing group, funding for food as well as yarn to make the blankets, can be mind-boggling.

A new school has been opened with over 50 pupils enrolled – Mama Betty's School For the Young – you bet I'm proud! Carlos and Joanne are still busy at Livingstone Memorial, and in their last letter mentioned their son David had been bitten by a black mamba – and actually lived. Needless to say, they are extremely thankful. Such are the trials of missionaries! I also was very surprised to hear from Dar that both Bobby and Fayez are now married to two beautiful sisters from India – arranged marriages. The whole family, as well as Betty Aunty, are thrilled.

Another trip? Of course, I simply must go and see Mama Betty's School and those new brides!

My love for the country and its people still sweeps over me, taking my breath away. When I look for a book to read, it's usually one on Africa; when I buy material, I'm drawn to African prints; when I look for a new picture, I see the giraffe; when I think of a holiday, Tanzania first comes to mind. I can't help but wonder, where does this intense love for the Dark Continent spring from?

One last word . . .

Readers wishing to send money, goods or assistance to the Kilangala Mission can do so by writing directly to the following address:

Kilangala Mission

P.O. Box 43

Sumbawanga

Tanzania

PRINTED AND BOUND
IN BOUCHERVILLE, QUÉBEC, CANADA
BY MARC VEILLEUX IMPRIMEUR INC.
IN JULY, 1997